A Treasury of Hours

© 2002, Desclée de Brouwer
76 bis Rue des Saintes-Pères, 75007 Paris
www.descleedebrouwer.com

Managing Editor: Claude Helft
Graphic design: Jack-Michel Verger
Layout: Mireille Cohedali and Anne-Marie Roederer
Production: Yves Raffner

First published in the United States of America in 2005 by Getty Publications
1200 Getty Center Drive, Suite 500
Los Angeles, California 90049-1682

English translation © 2005 The J. Paul Getty Trust
Text and illustrations pp. 32–33, 46–47, and 114–15 of this
present edition in English differ from the original French edition.
Christopher Hudson, *Publisher*
Mark Greenberg, *Editor in Chief*

Ann Lucke, *Managing Editor*
Abby Sider, *Copy Editor*
Sharon Grevet, *Translator*
Pamela Heath, *Production Coordinator*
Hespenheide Design, *Designer and Typesetter*

Biblical quotes from the Rheims-Douay version

Library of Congress Cataloging-in-Publication Data
Faÿ-Sallois, Fanny.
 [Trésor des heures. English]
 Treasury of hours / Fanny Faÿ-Sallois ; foreword by Dominique Ponnau.
 p. cm.
 Includes bibliographical references.
 ISBN-13: 978-0-89236-819-8 (hardcover)
 ISBN-10: 0-89236-819-5 (hardcover)
 1. Books of hours. 2. Illumination of books and manuscripts, Medieval. I
Title.
 ND3363.A1F3913 2005
 745.6'7—dc22

 2004025834

Law No. 49956 of July 16, 1949, on publications for young people
Photolithography: Labogravure, Bordeaux
Printed in France by Le Govic

Fanny Faÿ-Sallois

A Treasury of Hours
Selections from Illuminated Prayer Books

Foreword by Dominique Ponnau

THE J. PAUL GETTY MUSEUM
LOS ANGELES

Contents

* 5 see *Vocabulary
 and Short History*

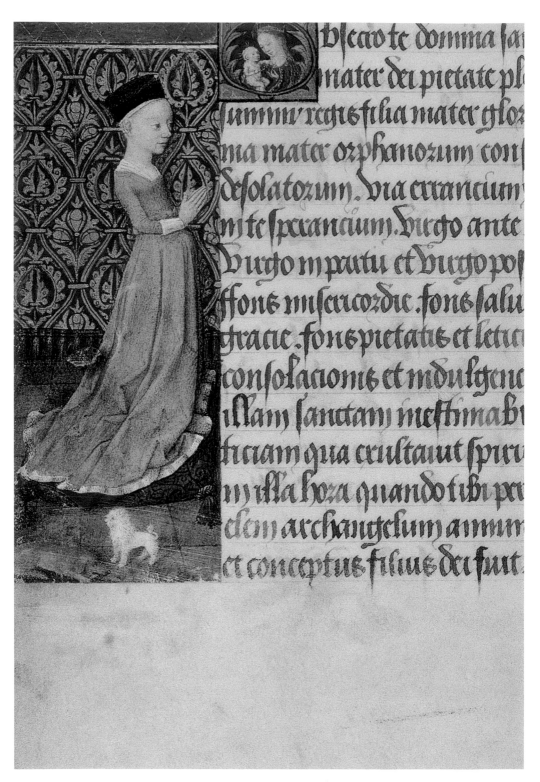

Young Woman Praying
Book of Hours, Use of Poitiers, ca. 1455–60

With the Passing of the Hours

If I had any advice to give, I would happily recommend approaching this book the way I did, as one opens a door—a door that opens onto a garden, an enchanted garden. Actually, a garden, a true garden, is always enchanted, since the garden par excellence is paradise. The first paradise and the last as well. The paradise of the very beginning of time and the paradise of the very end of time, when we will live—God knows—freed from everything, freed from time. But for now, we are living in the time of the meanwhile, hour by hour, day by day, until that day when the last hour strikes for us. Between the first and the last paradise of time, the garden of the meanwhile has invented its own points of reference, always where we expect them, but, here, always surprising. And as a result, we need fear neither confusion nor boredom, precisely because we expect the unexpected.

Imagine you are living at the time of the poet Villon's "Ladies of Yore" and of their lords. For that is the time of this garden of Hours. You just take a leap back from your time to that time. And there you are. You take your first timid steps, since you have come from such a distant time! And then you make yourself at home, and wander about, entirely at ease. You come, you go, you stop, you take a breath of fresh air on a bench, you walk some more, you move (no surprise) from surprise to surprise. You have fun identifying the flowers, the vines, the children, the angels, the giants, the not-so-ferocious beasts, the straddling monsters, the escutcheons, the birds—pelicans, swans, goldfinches, swallows, peacocks, ducks, jays, and nightingales—even sweet foxes—(sweet?) you do a double take!—at any rate, in those little spaces between the poppies and the bluebells are rabbits, monkeys, cranes, herons, cornflowers, irises, roses, hollyhocks, and lilies, naturally, and daisies, of course, open, wide open, or closed to sleep away the vesper time, the leaves—blue, blue like the blue-bird, red, orange, and green—and the snails! Not to mention the animal and vegetable species, impossible to name, impossible to enumerate. The border surrounding this garden is a celebration of hyperbole, very orderly, very rhythmic, where, now and again,

you recognize the garden version of the Happy Families game. And those families have names. There are family names, of course, and names of cities and countries too. Look. There is Étienne Chevalier, Louis de Laval, the Marshal of Boucicaut, Isabeau, Marguerite, Jean and Jeanne, Bavaria, Navarre, Orleans, dukes and duchesses of Rohan, Rome, Troyes, Chartres, Paris, the Coëtivy Master, and Jean, the Duke of Berry, just to name a few. The Use of the Hours depends . . . It depends on the weather, the time, the people, the customs of the place, and the customs of elsewhere as well. All of the Hours' borders of groves, bestiaries, and leaf patterns give you the keys to their images, my friends—the keys of sol, fa, and la. And we enter these musical images, and silently, religiously, joyfully, very simply sing.

Very simply? Easier said than done! The Hours, with all their animal and flower finery, their image and landscape robes, are, above all, Hours to decipher, to read, to pray. Who among you, my children, and among your parents, knows how to taste, to savor, in the little pot of honey, as sweet as it is bitter, the equally consuming and nourishing fire of the Burning Bush, the unbearable and living Word, that two-edged sword, the Word of God? However, these images, these singing landscapes, are not a delusion. They are offered to you "in their green rejuvenation," "in their first newness," but however far you wander in your cool promenade, it is with a view to what is hidden from you, since it is with a view to praying. If you only knew how beautiful are these mysterious prayers, depicted in the image, in the landscape. Even if you do not understand, listen! "Deus, in adjutorium meum, intende! Domine, ad adjuvandum me festina!" (God, come to my aid! Lord, hasten to help me!). Or listen to the prayer of the green lady kneeling in the image that accompanies these words, "Obsecro te, Domina Sancta Maria, Mater Dei, pietate plenissima, Summi Regis Filia, Mater gloriosissima, Mater orphanorum, Consolatio desolatorum" (I beseech you, Holy Lady Mary, most devoted Mother of God, both Daughter and most glorious Mother of the sovereign King, Mother of orphans, Consoler of the disconsolate). That is how it is. That is how it is in this beautiful Gothic book of spells, most often in musical Latin, and sometimes in Old French. That is how, my children, the heart of the lady sings from page to page, from image to image, from landscape to landscape. And that's how, I hope, your heart will sing as well. The Word. The living Word. It seems to me that, rather than understand It, it is infinitely better to listen to It, and, in the colorful silence, to hear It. You know, no one has ever got to the end of the mystery. I even gladly say that

the deeper you go, the deeper it gets; the more you drink it in, the more you thirst for it.

Wandering at the pace of the images, the landscapes, you must joyously accept that the groves of the Word remain for you labyrinthine paths for seeking the hidden treasure or the sleeping princess, a treasure that is already glittering in your heart, a princess who has already awoken in your heart. It is she who takes your hand in the garden and leads you to her!

But since you young gourmets of all ages must satisfy yourselves, sustain yourselves with more perceptible dishes, look at the images, the landscapes of those days. Look at the calendars, the seasons that, each in its time, returns year after year. Look at the four inspired men who recounted the Good News for you. Look, in whatever order you like, at the mystic story of the Virgin, always juxtaposed with the story of Jesus, her firstborn. Look at the Passion of that Son, whom we call Son of the Virgin, Son of God, and Son of man, and who, consequently, whoever you are, is your own son, your very own son whom you are now gazing upon—think about it—having gone back from your present time, hour by hour, to the time of those small and large Hours, when François Villon told us: "Brothers who live after we are dead / Harsh judgment of poor us eschew / For if you pity us instead / God may sooner take mercy on you."

François was, no less than we, but also no more, a contemporary of the Hours of God, the Virgin, and the saints. Every day of his life, from night to night, for him, matins, lauds, prime, terce, sext, none, vespers, and compline followed one another, over and over, always new, according to the rhythms of the year, according to the beats—regular as well as irregular—of his heart, until the hour when that heart beat no more. And so, my children, let us too walk in the beautiful garden, in time with him, in the beautiful Book of Hours that the kind and learned lady picked for us like a choice bouquet of flowers and medicinal herbs, to give us pleasure and—who knows?—to heal us . . .

Dominique Ponnau

April

Fair Easter-time,
With new-sprung verdure,
Offers leaf and flower
Of diverse allure,
Filling every lover
With mirth and rhyme

Bernard de Ventadour

In the garden of the Hours, let us begin our promenade in the company of these two handsome young people of noble, wealthy families. We are on the page for the month of April, since before the prayers, Books of Hours* illustrate the calendar.

In an idyllic landscape, under tall trees, the bushes are in flower.

On the calm water, disappearing into the blue of the mountains, a few small boats provide the only activity in this Garden of Eden.

The gallant squire whispers words of admiration to the sweet and elegant young damsel, whom we perceive to be both attentive and cautious.

The unknown painter frames this delicate image of spring with a strange architecture of columns enlivened by two large putti, those chubby-cheeked, golden cherubs.

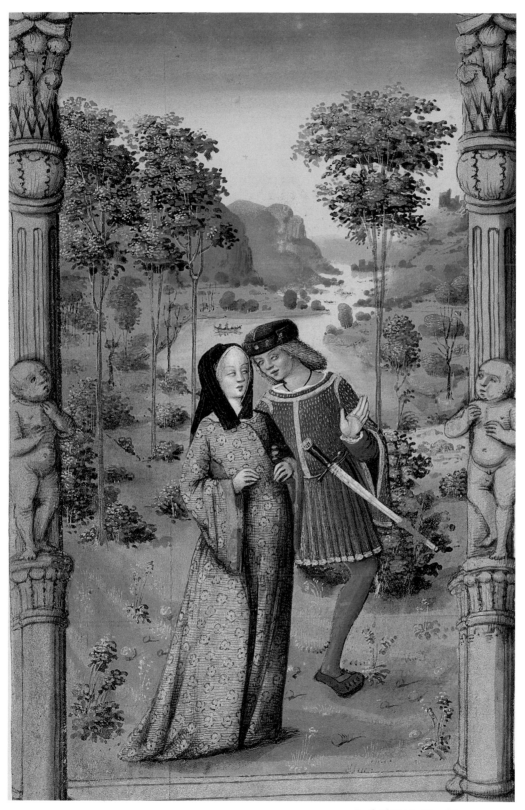

Book of Hours, Use of Rome, ca. 1500

July

Summer cloaks field, wood, and flower
With livery of verdure
And many another color,
As ordained by Nature.

Charles of Orleans

To the right of the days of the calendar, two peasants busy themselves with the harvest. One wields a scythe. The other, crouching, binds a sheaf of ripe wheat. A castle dominates the scene, and in the distance, a high wall mysteriously surrounds a mountain.

Like an echo of this classical illustration of work in the field, below the calendar a barefoot peasant raises his hoe. A few steps away, his wife plies her distaff, while keeping an eye on her children. The eldest has his back to his father, while the newborn, eyes wide open, rests in his cradle.

In reality, legend teaches us that the artist was painting Adam and Eve, condemned to toil after their expulsion from paradise, and their two sons, Cain and Abel. In this way the *Book of Hours of Louis de Laval** regularly mixes images of daily life and biblical scenes.

The coat of arms of Louis de Laval adorns the third frame, as it does each of the twelve calendar pages of his Book of Hours.

In the margins, perhaps in response to the mortal combat that will take place between the two brothers, curious pink cherubs with black wings and black devils with pink wings frolic among the flowers.

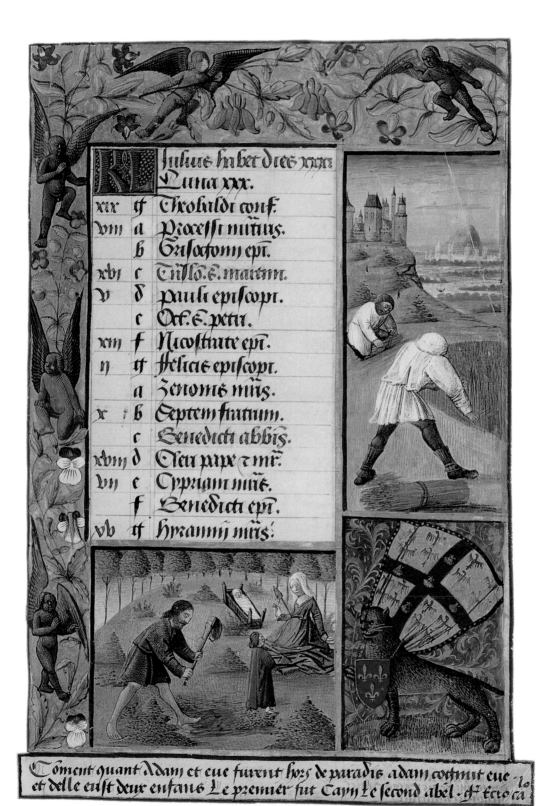

October

We speak of grand seigniory,
Of holding mighty castles and towers;
But is there any joy that is sweeter
Than to regard a field of beauty?

Arnoul Gréban

On the Left Bank, now in the heart of Paris, fields stretched all the way to the river, edged with a row of tousled willows. Curiously draped in white, a handsome horse pulls a harrow, weighted down by a heavy stone. A rustic rider guides the horse with the reins and threatens it with a whip. Behind them, a peasant scatters seeds, which the crows and magpies immediately fight over.

In the middle distance, a scarecrow archer and a network of threads stretched on stakes protect a parcel, which has already been seeded, from the voracious birds.

On the Right Bank, on the other side of the Seine, stand towers and the large keep of the magnificent castle of Charles V, the brother of the patron.* Just one small door in the high wall opens onto the embankment. There, friends chat. People walk their dogs. People work too. Two washerwomen, with their feet in the water, beat laundry on the bottom step of a stairway.

The calendar of the month, signs of the zodiac (Libra and Scorpio), and a surprising chariot of the sun top this miniature, whose author—contrary to most of those found in the *Very Rich Book of Hours of the Duke of Berry**—is anonymous, despite all his talent.

18

Calendar

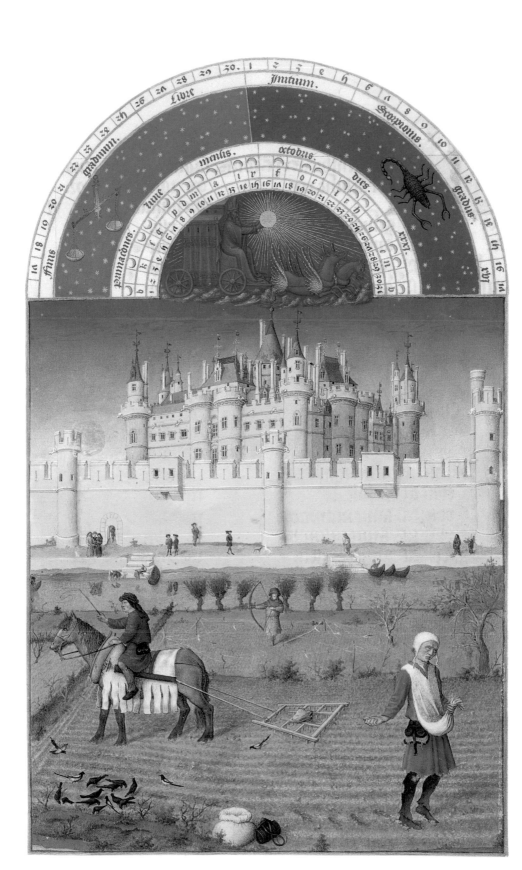

Very Rich Book of Hours of the Duke of Berry, ca. 1440

December

And the waters returned from off the earth going and coming: and they began to be abated after a hundred and fifty days. And the ark rested in the seventh month, the seven and twentieth day of the month, upon the mountains of Armenia.

Genesis 8:3–4

20

A surprising construction tops the heavy hull of the ark, weighted down by all the animals of creation. Under a roof that resembles that of a chapel, an aviary holds multicolored birds.

The floodwaters have receded. Noah; his wife; their three sons, Shem, Ham, and Japheth; and their wives are relieved to see the mountaintops emerging from the waves.

Noah points at the raven that he has just released as a scout to determine whether the waters have indeed completely receded. But the caption under the image tells us that the bird, too busy feeding on carrion, did not return.

The biblical scene is set into an artful frame matching that of the ark, made entirely of finely sculpted wood. The image is very original compared with the calendars in other Books of Hours, which generally use an illustration of a pig being slaughtered, a seasonal activity for the month of December.

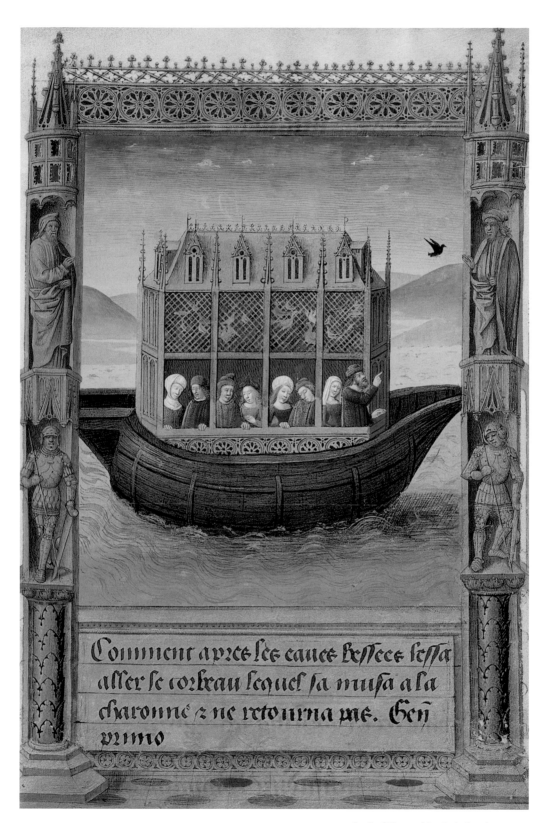

Comment apres les eaues besses lessa
aller le corbeau lequel sa musa a la
charonne z ne retourna mie. Gen
vimo

Book of Hours of Louis de Laval, ca. 1480

John the Evangelist

After the twelve months of the calendar, Books of Hours often provide portraits of Matthew, Mark, Luke, and John to illustrate the passages from the Gospels. The evangelists' accounts of the life and teachings of Jesus constitute the biblical New Testament. John was the beloved disciple of Jesus, the one whom Christ on the cross chose to watch over Mary.

Only the inscription on the parchment, at the center of this dazzling gilt image, makes it possible to identify John. Comfortably seated in front of his desk in an openwork sculpted wooden stall, the young apostle takes a short pause from writing his Gospel. He pushes out his beardless cheeks and blows on his pen. Is it to dry the ink or to find inspiration?

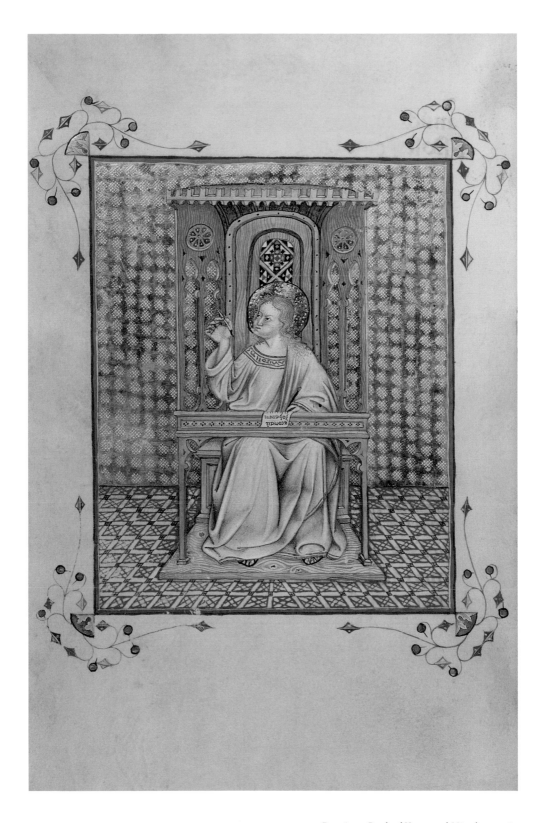

Luke the Evangelist

Mother of Christ
Mother of Divine Grace
Mother most Pure
Mother most Chaste
Mother Undefiled
Mother most Amiable . . .

The Litany of the Virgin Mary

Luke paints an icon of the Virgin. She appears to him as in a dream, all dressed in blue, eyes lowered, and hands pressed together.

Luke is draped in a long scarlet robe and wearing a dark hat. He works assiduously, indifferent to the vast landscape over which an intense blue night is falling. He applies the colors without even looking up at the Virgin. The dual Latin inscription at the bottom of the miniature specifies that this is the Virgin of the Annunciation.

The small, nearly complete portrait is resting on an easel, whose immaculate whiteness, a symbol of the Virgin, gleams in the center of the image.

The painter, Jean Colombe,* sets Luke's workshop in a rich frame of Gothic architecture that emphasizes, by contrast, the simplicity of the room.

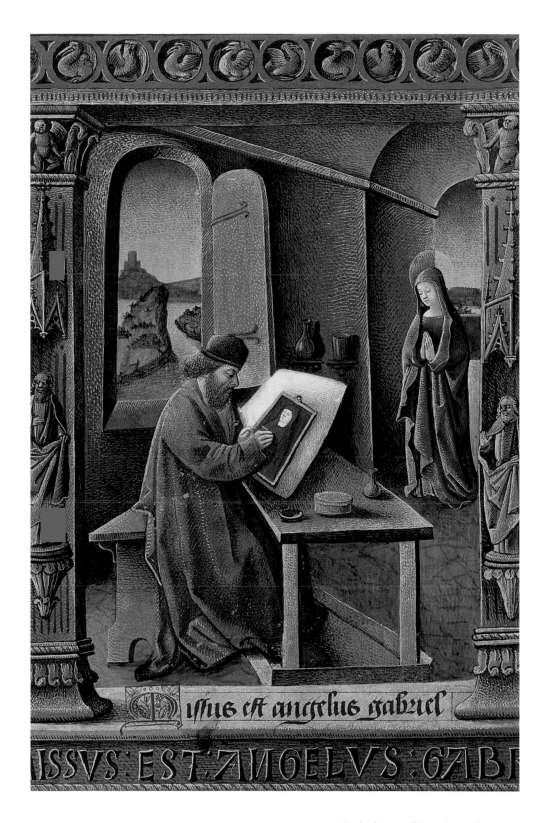

Missus est angelus gabriel

ISSVS · EST · ANGELVS · GAB

Matthew the Evangelist

*And when ye pray, you shall not be as
the hypocrites, that love to stand
and pray in the synagogues and cor-
ners of the streets, that they may be
seen by men. . . .*
*But thou when thou shalt pray, enter
into thy chamber, and having shut
the door, pray to thy Father in
secret, and thy Father who seeth in
secret will repay thee.*

The Sermon on the Mount
The Gospel according to Saint Matthew 6:5–6

Through the open door, the rays from the Holy Spirit light the desk and dapple Matthew's long blue robe.

Concentrating on his task, his beardless face topped with a high red cap, Matthew writes on the right-hand page, while holding his erasing knife in his left hand.

A constellation is outlined on the dark ceiling. A charming little angel in a white alb watches over the Gospel-writer and holds out a heavy black inkwell to him. In counterpoint, exuberant flowers, fruits, and butterflies frolic in the margins. A peacock fans a magnificent tail. But what is that strange animal, perched at the top of the fountain, turning its back to the scene?

Passages from the Gospels

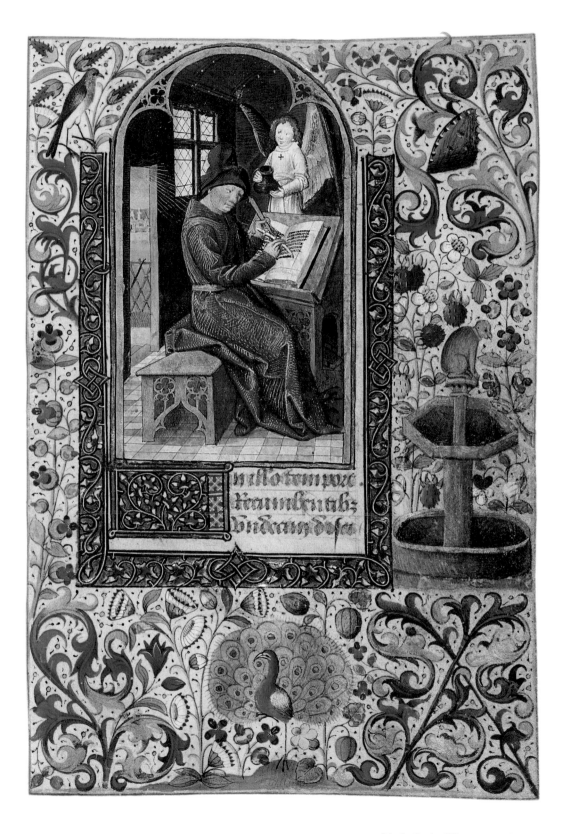

Rivoire Book of Hours, ca. 1465–70

Mark the Evangelist

A lion? A canal? We are in Venice, even if the charming houses in the background are entirely imaginary.

Mark the Evangelist has been the patron saint of Venice since the Venetians brought back his relics from Alexandria in the year 829.

He did not know Christ, but he heard the accounts of his disciple Peter. Thus, he wrote the second gospel, the shortest of the four.

Here he is enveloped in an ample blue mantle over his scarlet robe.

He turns away from his desk for a moment. As he sharpens his quill, he contemplates his work with a preoccupied expression.

Passages from the Gospels

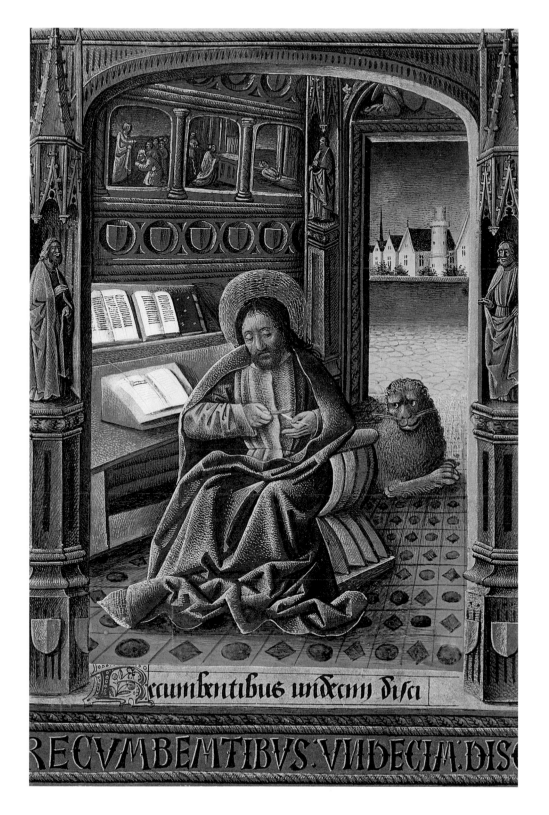

Marguerite of Orleans
Praying to the Madonna

God, who led the children of Israel dry-
shod through the sea, and showed the
way to the three Magi by the guid-
ance of a star; grant these pilgrims,
we pray, a happy journey and peace-
ful days, so that, with Your holy
angel as a guide, they may safely
reach their destination and finally
come to the haven of everlasting
salvation.

The Blessing of the Pilgrims

The portrait of a praying patron—also called a donor—opens the various cycles of the Hours, throughout the pages and the images. Here, it is a female patron—the young (very young) Marguerite of Orleans—who introduces the Hours of the Virgin. She is kneeling before the Madonna, shoulders straight, back arched, hands assiduously pressed together. She addresses the child, who holds out his arms to her and hears her prayer.

Under a canopy, the Virgin humbly lowers her eyes. Two blue seraphim place her Queen of Heaven's crown atop her halo.

In the frame is a scene as gracious as it is pious: a pilgrimage to Santiago de Compostela. Alone or in pairs, on horseback or on foot, the pilgrims cross fields and forests on the winding path. Sometimes they stop to talk, rest a moment, or quench their thirst before taking up their staffs again. Marguerite is there, too, astride her white horse, alone, among the birds and flowers.

Hours of the Virgin

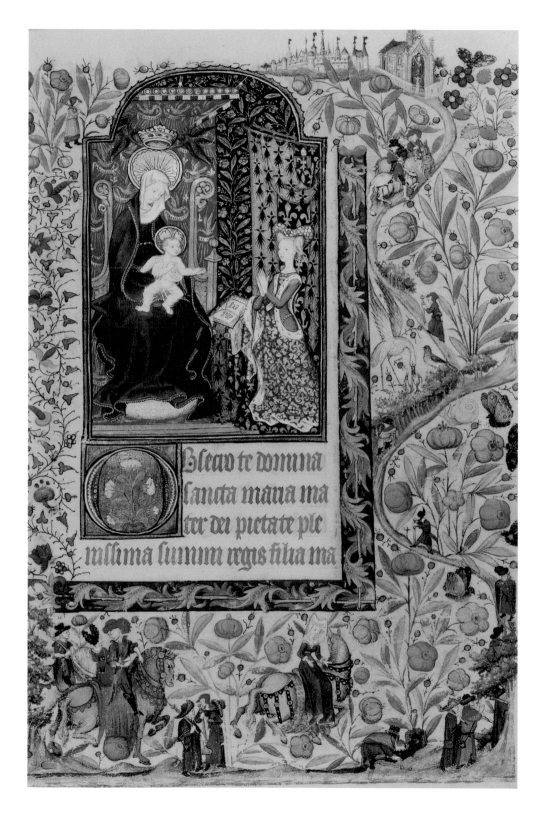

Book of Hours of Marguerite of Orleans, ca. 1430

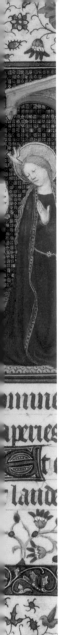

The Annunciation

*And in the sixth month, the angel
 Gabriel was sent from God into a
 city of Galilee, called Nazareth,
To a virgin espoused to a man whose
 name was Joseph, of the house of
 David: and the virgin's name was
 Mary.
And the angel being come in, said unto
 her: Hail, full of grace, the Lord is
 with thee: blessed art thou among
 women.
Who having heard, was troubled at his
 saying and thought with herself
 what manner of salutation this
 should be.*

The Gospel according to Saint Luke 1:26–29

The Hours of the Virgin illustrate the beautiful story of the childhood of Jesus. They begin with the Annunciation, the extraordinary news that the angel Gabriel announces to Mary: that she will have a son who will be called the "Son of God." The banderole that curls around the angel's left arm contains the beginning of his greeting: "Hail Mary, full of grace." Kneeling in prayer, the Virgin has paused from her reading. She turns her head to listen and understands the angel's words. With a gesture of her right hand, she indicates, "Behold the handmaid of the Lord: be it done to me according to thy word."

Above Gabriel, God the Father sends forth the Holy Spirit, seen in the form of a dove that descends toward Mary. The blue, green, red, and gold of the ornamental background are repeated in the garments of the Virgin and the angel, creating a sumptuous, jewel-like effect.

32

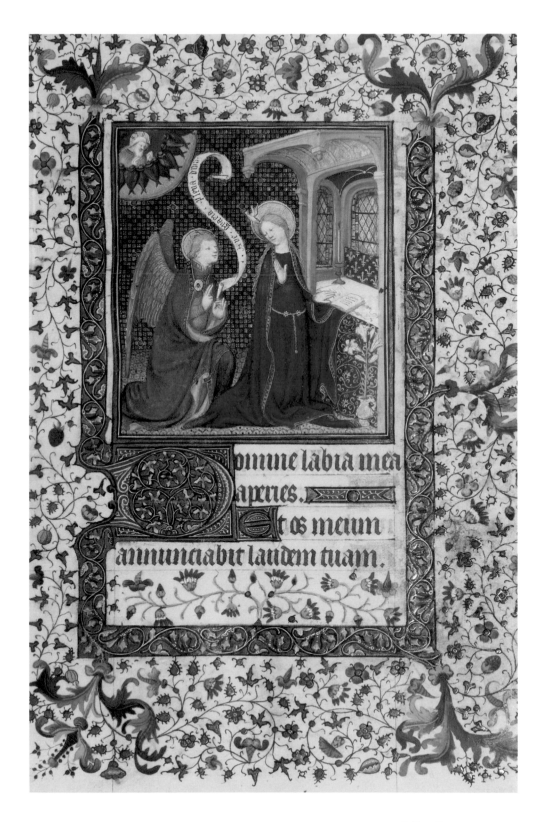

Balfour Hours, ca. 1415–20

The Visitation

*And Mary said: My soul doth magnify
 the Lord.*
*And my spirit hath rejoiced in God my
 Savior.*
*Because he hath regarded the humility
 of his handmaid: for behold from
 henceforth all generations shall call
 me blessed.*
*Because he that is mighty hath done
 great things to me: and holy is his
 name.*
*And his mercy is from generation unto
 generations, to them that fear him.*

The Song of Mary
The Gospel according to Saint Luke 1:46–50

The angel Gabriel also announces to Mary that her cousin, Elizabeth, is six months pregnant with a male child, despite her advanced age. Mary soon pays her a visit.

Here are the two of them together. Elizabeth bends her knee to Mary, who stops her with a delicate gesture. Her hand on the ample robe and rounded belly of the Virgin, Elizabeth cries out, "Blessed art thou among women and blessed is the fruit of thy womb! And whence is this to me that the mother of my Lord should come to me? For behold as soon as the voice of thy salutation sounded in my ears, the infant in my womb leaped for joy!" (Luke 1:42–45). Mary then intones the splendid hymn of thanksgiving that we call the Magnificat, or Song of Mary.

The miniaturist records the meeting of the mothers of Jesus and John the Baptist, so profound and so solemn, in the sparing decor of a chapel with stone ogives. Nothing disturbs the intensity of their relationship, not even the birds that enliven the border of foliage or the lost dog that looks like it is barking.

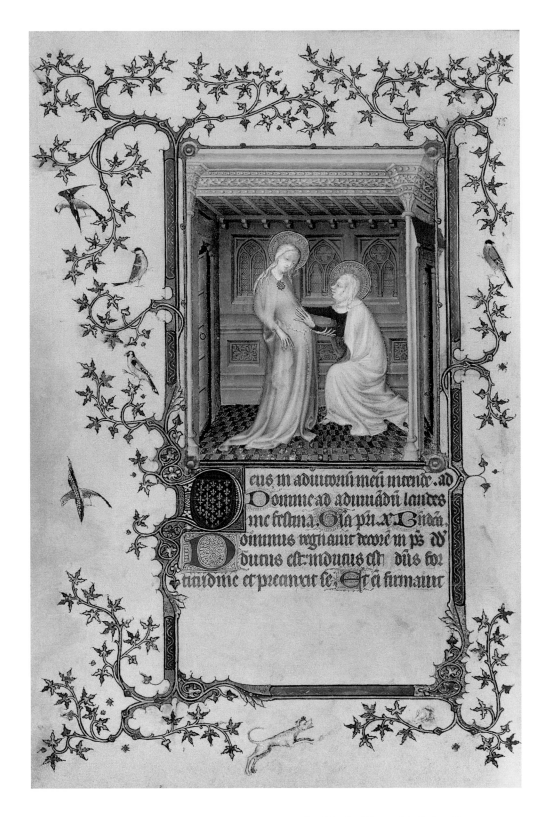

Small Book of Hours of the Duke of Berry, ca. 1385

The Nativity

The divine child is born! In a carpenter's ideal of a crèche, he rests on blue-bordered swaddling clothes. A rich canopy hangs down into a coverlet. Without raising his haloed head from his green cushion, he blesses Mary.

She puts her hands together over her prayer book, elegantly draped in her mantle. Joseph, more simply attired in his robe belted with a rosary, approaches like a pilgrim, gourd and staff in hand.

The donkey and the ox are much too far away, behind the manger, to warm the newborn, but ears high, the donkey tilts his head toward him.

Two cherubs surround the little child. The rays of the Holy Spirit pierce the roof and envelop him in light.

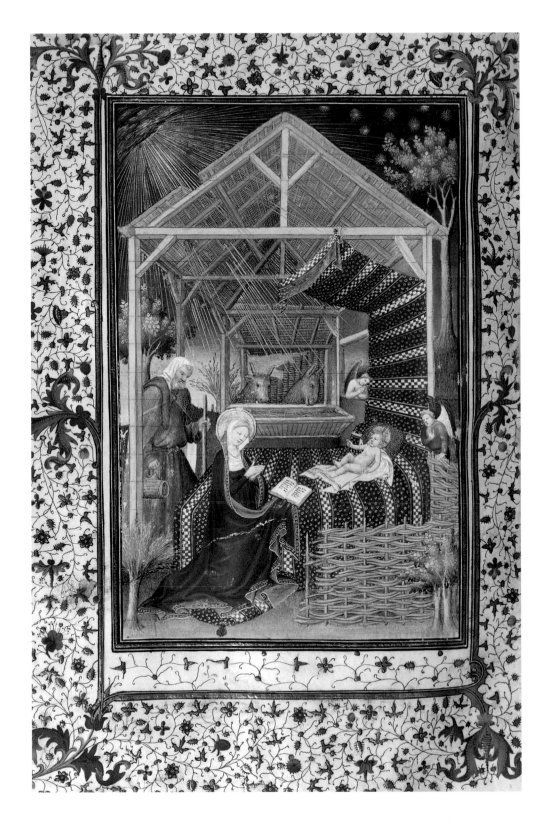

Book of Hours of the Marshal of Boucicaut, ca. 1405–8

The Bathing of the Christ Child

Morning star,
O very gentle lady,
blessed be your mouth,
blessed be your arms

Prayer to the Virgin, fifteenth century

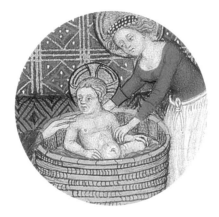

Enveloped in the folds of his old rose–colored cape, Joseph dozes at the feet of the Virgin Mary. She rests, dressed in deep blue, on a comfortable, wide, high scarlet bed. Sitting up slightly, she holds her haloed head with one hand and lightly touches baby Jesus' shoulder with the other. Sitting upright in his wooden tub, he looks at her intensely, as a kneeling servant in a white apron takes care of him.

This charming scene does not appear in the accounts of the Gospels. But the imagination and ardor of the miniaturist drove him to paint this moment of the newborn relaxing at bath time in a rich decor, saturated with color, from the painted walls to the green ceramic tile floor. This image is constructed around two diagonals. One runs from Joseph to the servant, the other along the Virgin's bed. The gesture of Mary's hand toward the child is located at the juncture of the two lines. This placement emphasizes the mystery of the Incarnation, which, for Christians, seals the covenant between God and man.

38

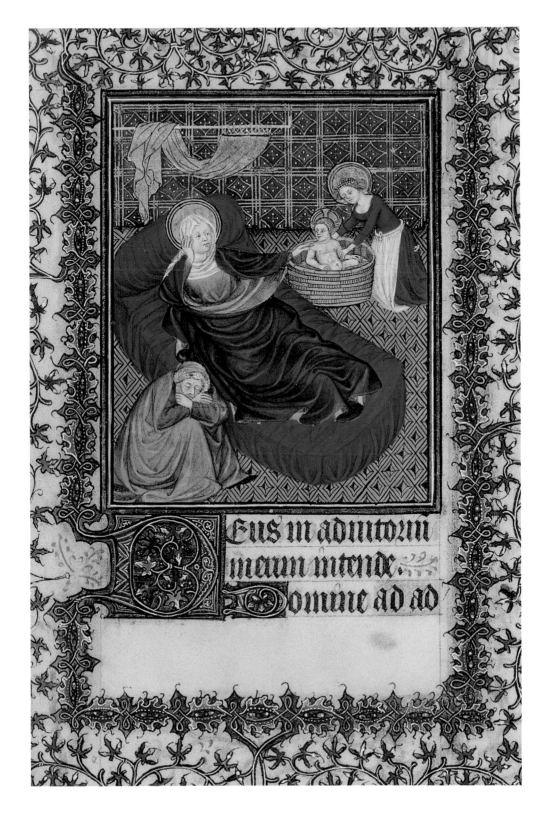

The Annunciation to the Shepherds

And there were in the same country
shepherds watching and keeping the
night watches over their flock.
And behold an angel of the Lord stood
by them and the brightness of God
shone round about them: and they
feared with a great fear.
And the angel said to them: Fear not;
for, behold, I bring you good tidings
of great joy that shall be to all the
people:
For, this day is born to you a Savior,
who is Christ the Lord, in the city of
David.

The Gospel according to Saint Luke 2:8–11

In the calm night, shepherds watch. Their sheep rest some distance from the village, in a small, green prairie at the edge of a pretty river traversed by a small wooden bridge. A white swan and, above, a duck swim the river in silence. Suddenly, a divine light surprises the shepherds. Struck with emotion, the eldest places his hand on his forehead and starts walking in quite a dangerous position. Behind him, a more serene companion places his hand on his neighbor's shoulder and reassures him by repeating the angel's words.

Only the shepherds' dog, looking like Saint Francis's "Brother Wolf," raises his eyes to the angels. Surely, it was he who first saw them unfurl the streamer, called a phylactery,* that renders "glory to God on high."

Hours of the Virgin

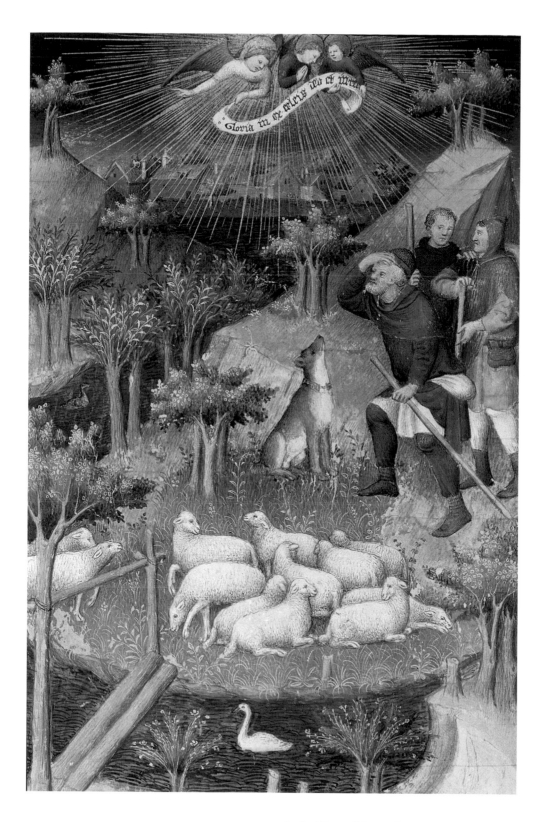

Within the illustration, on the banner:

Gloria in excelsis deo et in terra

Book of Hours of the Marshal of Boucicaut, ca. 1405–8

The Epiphany

When Jesus therefore was born in
 Bethlehem of Judah, in the days of
 King Herod, behold, there came wise
 men from the East to Jerusalem,
Saying: Where is he that is born king of
 the Jews? For we have seen his star
 in the East, and are come to adore
 him.

The Gospel according to Saint Matthew 2:1–2

The Wise Men, who came from the three continents that were known at the time, came to worship the new lord of the world. Painters and miniaturists often use the scene as a pretext for magnificent decor. Nothing of the sort here. No contrast between the misery of the cowshed and the opulence of the kings, between the exotically clad mounts and the rustic donkey. No procession or vast landscape. Even Joseph is absent from the image. There is only Mary, the child, and the three legendary kings: Melchior, Caspar, and Balthasar.

The eldest is the first to remove his crown and rush to the feet of the newborn. With one hand, he seizes the hand of the baby and presses it to his white beard, and with the other he holds out his gift to the Virgin, never taking his eyes off the child, who blesses him. Seated in a Gothic stall, feet resting on a red stool, Mary delicately approves her son's benediction.

Beyond, golden chalices in hand, the two other kings approach. The younger views the scene and prepares to remove his crown and place it at the divine child's feet.

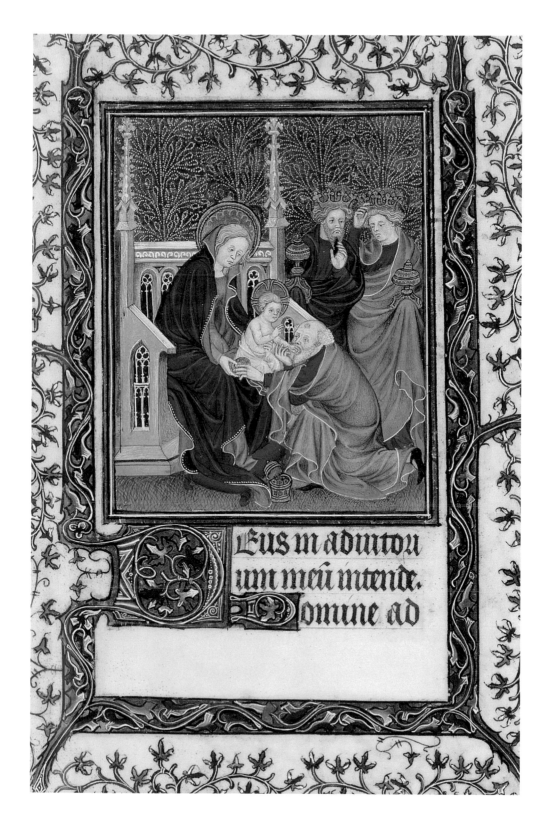

The Canticle of Simeon

*And behold there was a man in
Jerusalem named Simeon: and this
man was just and devout, waiting for
the consolation of Israel. And the
Holy Ghost was in him.*
*And he had received an answer from the
Holy Ghost, that he should not see
death before he had seen the Christ
of the Lord.*
*And he came by the Spirit into the
temple. And when his parents
brought in the child Jesus, to do
for him according to the custom
of the law,*
He also took him into his arms

The Gospel according to Saint Luke 2:25–27

The image is entirely one of devotion, ardor, and solemnity.

Simeon the just and pious hands the child, whom he has blessed, to Mary, after saying, "Now thou dost dismiss thy servant, O Lord, according to thy word in peace" (Luke 2:29).

A haloed Mary receives the Son of God humbly, on her knees, before the temple door. The naked baby, placed on white swaddling clothes, is happy to return to his mother and holds out his arms to her. Joseph, standing behind Mary, looks down on the caption about the very old prophetess Anna, "who departed not from the temple, by fastings and prayers serving night and day" (Luke 2:37).

We see two faces behind Simeon. Perhaps one of those faces is that of a patron.

A frieze of daisies separates the miniature from the border, whose elegant and hectic decoration contrasts with the solemn attitudes of the sacred scene—birds move through a subtle interlacing of leaves, flowers, and fruits, while a savage* beats a strange monster with a club.

Hours of the Virgin

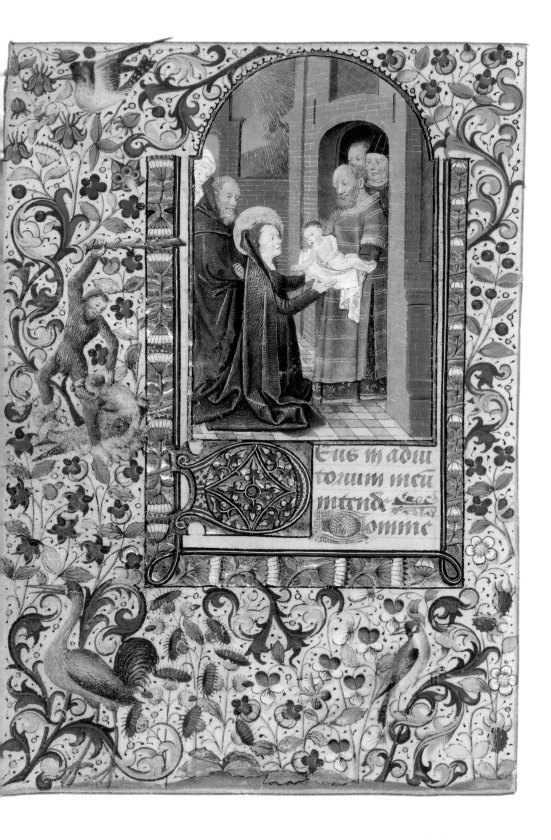

Rivoire Book of Hours, ca. 1465–70

The Flight into Egypt

*And after they were departed, behold an
angel of the Lord appeared in sleep
to Joseph, saying: Arise, and take
the child and his mother, and fly
into Egypt: and be there until I
shall tell thee. For it will come to
pass that Herod will seek the child
to destroy him.*

The Gospel according to Saint Matthew 2:13

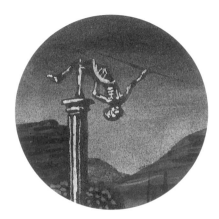

After the commandment of King Herod to murder all the newborn infants
in Bethlehem and its environs, the Holy Family, warned by an angel, flees to
Egypt. Dressed in luminous blue and red robes, Mary and Joseph make their
way through a lush landscape that resembles the French countryside. The
infant Jesus is dressed in swaddling clothes and is tenderly cradled in his
mother's arms.

In the background behind the group a pagan idol topples, symbolizing
the change from the Old Dispensation to the New. The soldiers by the
wheat field illustrate an apocryphal story. As the Holy Family passed a
field of newly sown wheat, it miraculously grew to full height. When
Herod's soldiers asked a farmer when the travelers passed, he answered
honestly, "When the wheat was planted." Discouraged, the soldiers gave
up their chase.

46

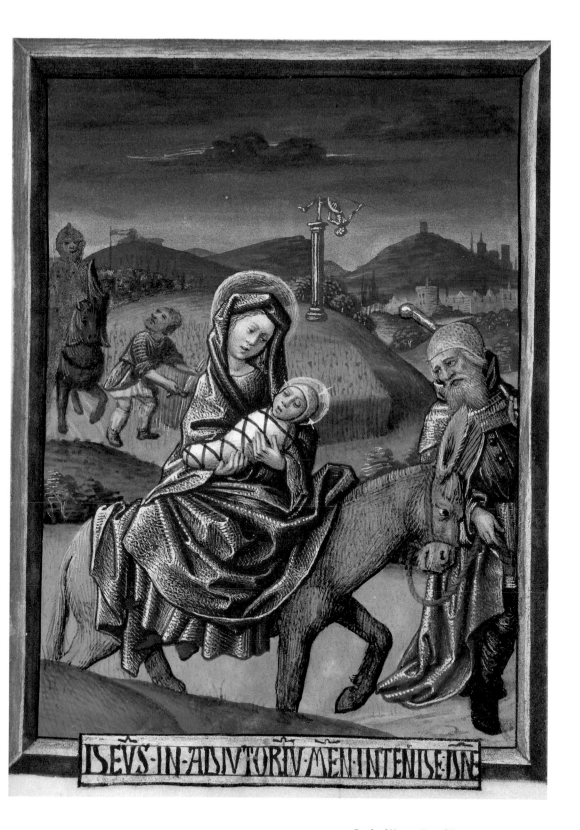

Book of Hours, Use of Rome, ca. 1415–25

The Wedding at Cana

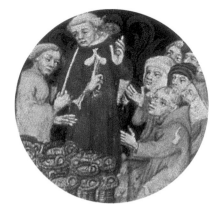

And the third day, there was a marriage in Cana of Galilee: and the mother of Jesus was there.

And Jesus also was invited, and his disciples, to the marriage.

Now there were set there six waterpots of stone, according to the manner of the purifying of the Jews, containing two or three measures apiece.

Jesus saith to them: Fill the waterpots with water. And they filled them up to the brim.

And Jesus saith to them: Draw out now and carry to the chief steward of the feast. And they carried it.

The Gospel according to Saint John 2:1–2 and 6–8

Far from Galilee, the wedding meal is served under a beautiful barrel vault adorned with finely worked ogees. Beside the young bride, the Virgin Mary, hands pressed together, leans toward Jesus, who has just performed his first miracle by changing water into wine.

At left, the host has tasted the wine and expresses his surprise to his neighbor, probably the mother of the bride. In front of the table, two kneeling figures busy themselves, one with presenting six pots now filled with wine, and the other with carving food. All appears simple in this beautiful image. But it has a hidden meaning.[1]

In the historiated initial,*gathered poor folk hold out their hands to baskets full of bread. Two disciples are amazed at the miracle of the multiplication of the loaves.

Flourishes* of wispy flowers and quatrefoil medallions* escape from the cable molding that frames the page, attributed to the painter Jacquemart de Hesdin.*

Four repetitive motifs appear in the medallions: the coat of arms of the Duke of Berry, the initials V. E., a bear carrying the banner of the Duke of Berry, and, finally, a swan with a bleeding breast, a symbol of Christ.

1. See at the end of the book, in "Short History of Princes," the entry *Large Book of Hours of the Duke of Berry*.

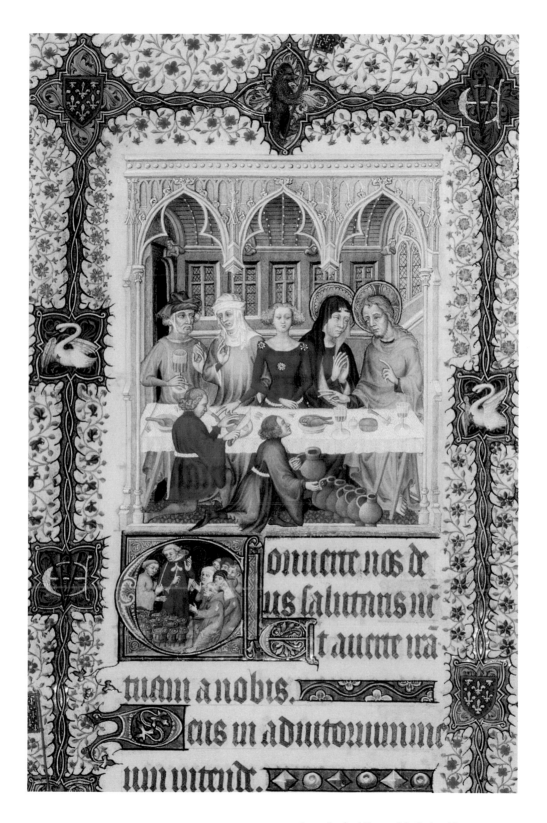

Large Book of Hours of the Duke of Berry, ca. 1409

The Crowning of the Virgin

Mary was taken up into heaven, [and]
the Angels rejoice and with praises
bless the Lord.

August 14, First Vespers,
Psalms of the Virgin

Well before the 1950 papal proclamation of the dogma of the Assumption, miniaturists depicted the Virgin being carried to heaven by angels, there to be crowned by her son, the Christ, or by the Trinity. Here, exceptionally, it is God the Father—enthroned beneath a tent, wearing a three-crowned diadem, and holding a globe surmounted with a cross in his left hand—who blesses Mary. Three angels prepare to crown the Queen of Heaven, as two others hold her robe, and another perfumes her with a censer.*

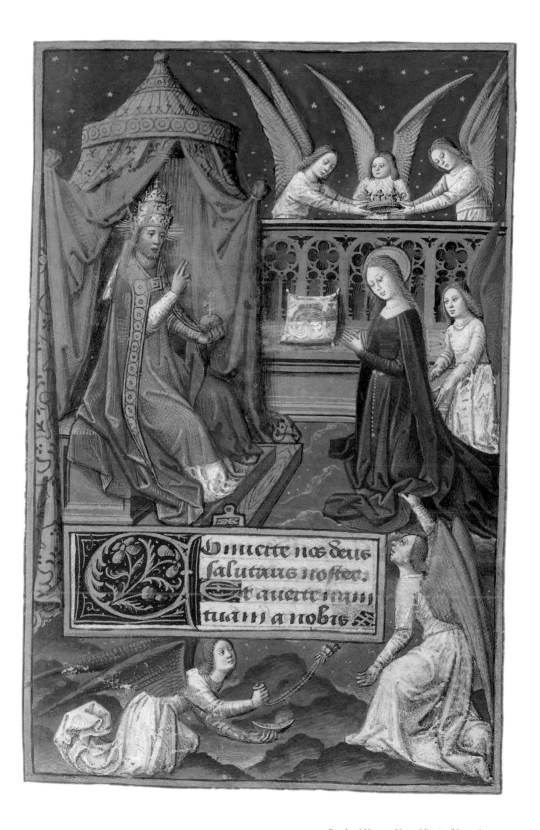

Book of Hours, Use of Paris, fifteenth century

Praying Patron

A large, marble-edged terrace opens onto the sky and the treetops. A noble lady kneels there in prayer. She lifts her handsome face toward the Virgin, who tenderly holds the child, cheek to cheek. The sovereignty of the Queen of Heaven is discreetly suggested by the throne enveloped by her robe and by her crown surmounted by a fleur-de-lis. She is accentuated by the multitude of blue angels surrounding the indefinable cloud where mother and child are seated.

The coat of arms on the tablecloth does not identify the patron, but the care with which Jean Fouquet* painted her portrait leaves no doubt as to her status. The richness of her attire, the long brocade dress edged in ermine, and the heavy gold necklace testify to her nobility. Behind her, four girls wear the same headdress held in place by a black band.

The first one, perhaps her daughter, resembles the patron in her dress and necklace, and in the Book of Hours open on her lap.

Probably one of the last works by Fouquet, this page, admirable in its harmony and subtlety, is at the beginning of the *Baudricourt Book of Hours.** It arranges the patron and the Queen of Heaven in classic fashion. More unusual is its depiction of the Book of Hours itself, in which the "Obsecro te*—also inscribed in the miniature, on the banner beneath the ermine hem—occupies the first place.

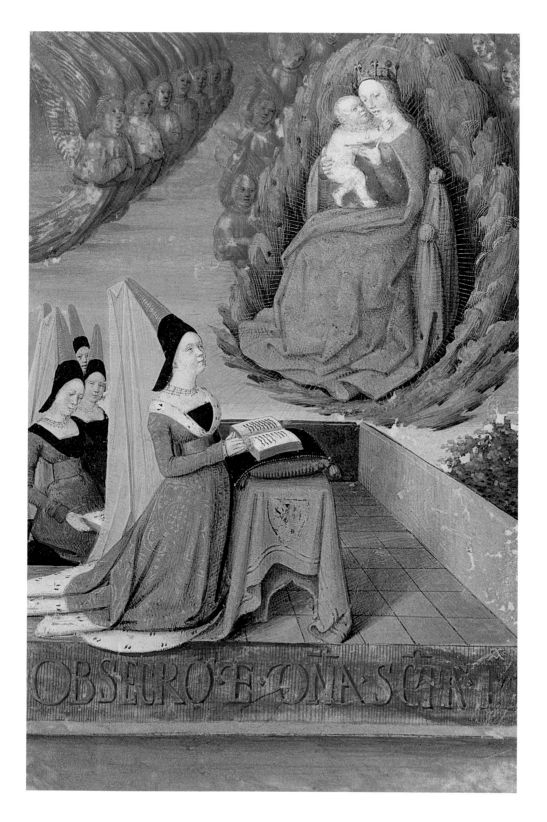

"Baudricourt" Book of Hours, ca. 1470

The Nursing Virgin

*Lady, you who were mother and nurse
and guardian to the King of Justice,
by your blessed mercy, counsel
my spirit, which is filled with malice.*

Prayer to the Virgin, early fifteenth century

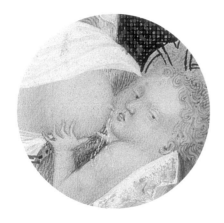

With a "nurse's tranquil lack of prudery,"[1] the Virgin offers her breast to the child, who grasps it with both hands and turns away from it for a moment, as if taken by surprise by the painter's brush. The mother's graceful body, the delicate ballet of her slender hands, and the child's tiny feet—everything exudes the grace of earthly life.

Unlike the austere maternal scenes of earlier manuscripts and despite the Virgin's serious and contemplative face, this image, like others of the fifteenth century, expresses a new sensibility, in which the body and the emotions are imbued with joyousness.

To the left of the Virgin, Moses slays the worshippers of the golden calf.

1. Émile Mâle, *Les Grandes Heures de Rohan* (Geneva, 1947).

Prayers to the Virgin

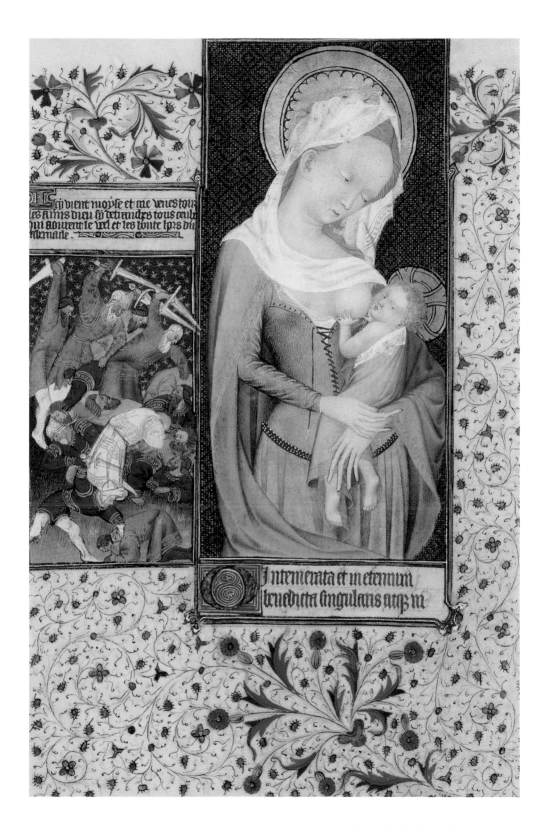

Rohan Book of Hours, fifteenth century

The Mass of Saint Gregory

Most blessed Gregory,
help me to share in the Passion
of Our Lord Jesus Christ.

Marguerite of Valois

The miniature* that opens the Hours of the Passion depicts the miracle that occurred during a Mass celebrated by Pope Gregory the Great. During the Eucharist, when the pope raises the host, Christ appears. He bears the signs of the Crucifixion, the stigmata.

He is surrounded by the Virgin Mary and one of his disciples, John.

The instruments of his torture—hammer, nails, and pincers—rest on the tomb that is joined to the altar. The crown of thorns above Jesus' halo is green.

"Christ is dead, Christ is risen." The miraculous Mass reveals the union of the mystery of the Passion and the Eucharist.

Two other figures are witnesses to the vision: the acolyte,* lighted candle in his hand, who holds up the brilliant red chasuble of the reigning pope, and the nephew of the Marshal of Boucicaut, Marshal Jean III le Meingre. He inherited his uncle's Book of Hours and asked the painter to depict him kneeling in prayer. His device, "Et puis ho la" (Have an end to it), is repeated in the flowery frame.

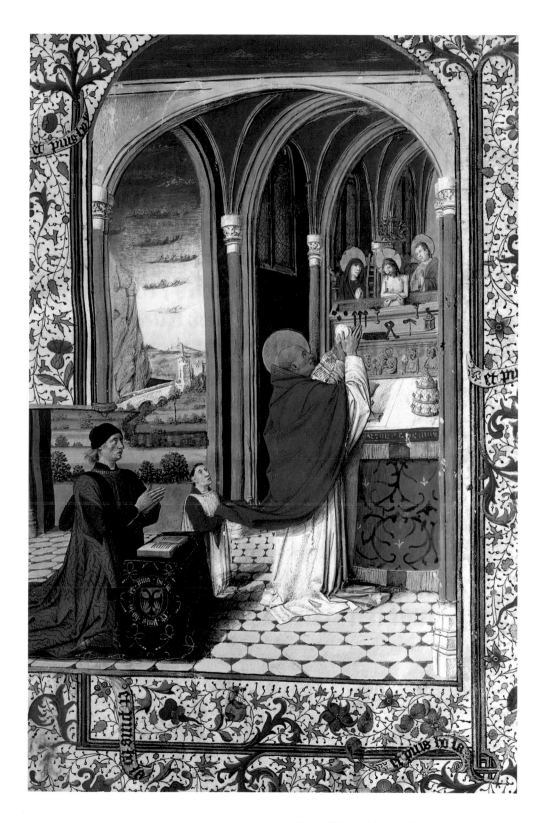

Book of Hours of the Marshal of Boucicaut, ca. 1477

At the Mount of Olives

And going out, he went, according to
his custom, to the Mount of Olives.
And his disciples also followed him.
And when he was come to the place, he
said to them: Pray, lest ye enter into
temptation.
And he was withdrawn away from them
a stone's cast. And kneeling down, he
prayed.
Saying: Father, if thou wilt, remove this
chalice from me: but yet not my will,
but thine be done!

The Gospel according to Saint Luke 22:39–42

The miniatures from Hours of the Passion depict the final days in the life of Jesus and his Resurrection according to the Gospels. The account begins at night, two days before the Feast of Passover, celebrating the Exodus of the Hebrews from Egypt, led by Moses.

Deaf to the words of Jesus, "My soul is sorrowful even unto death. Stay you here and watch with me" (Matthew 26:38), the apostles he chose to accompany him to the Garden of Gethsemane—Peter, James, and John—are asleep, huddled against each other.

Jesus has moved a short distance away. He climbs onto a rock, bringing him closer to heaven. His face is transfigured and imploring. The city of Jerusalem stands out in the distance against the starry night. In the darkness, a cohort, lighted by torches and armed with swords, is coming to arrest Jesus. Judas leads them. The contrast between the supernatural light in the foreground and the shadows that stop at the garden gate emphasizes the impending drama. Jean Colombe soberly frames this tragic night with a Gothic embellishment watched over by two angels.

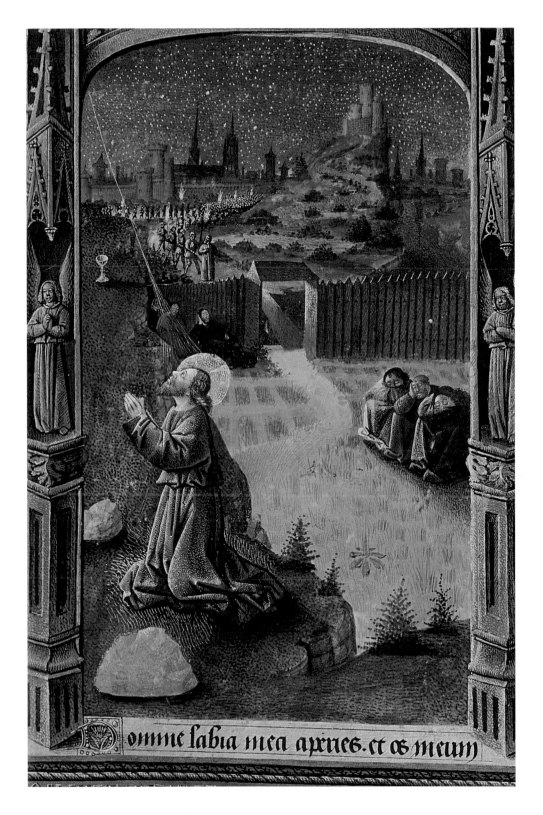

omine labia mea apꝛies. et os meum

Jesus before Pilate

60

Jesus is brought before the Roman governor, Pilate, by three guards, who present Jesus to him. They hold him bound, hands tied, as if they fear he might escape. One of them, grimacing, on his knees, demands the death of Jesus. Pilate turns his face away from Jesus, who stares at him as he washes his hands. The guard who pours water from the jug holds a towel on his shoulder, for drying Pilate's hands. The robust figures, who appear uncultivated and archaic, stand out against the gold and blue checkerboard background. Below, in the initial, is a simple illustration of the Nativity: the donkey and ox blow on the child to warm him. Joseph watches over them, and Mary places her hand gently on her newborn.

Branches of grape leaves escape from the gold frame, below which a hare, a symbol of life, bursts from his burrow, and above which a knight with raised shield fights a winged dragon with his sword.

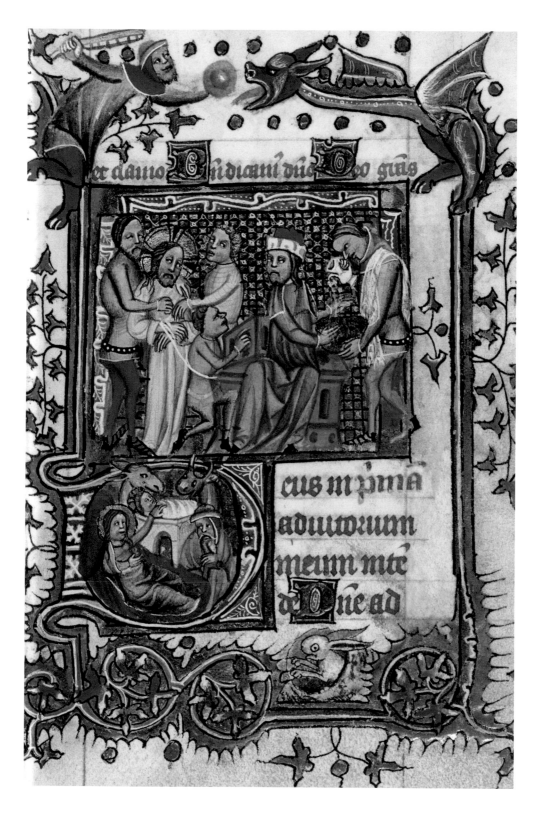

Book of Hours, Use of Metz, or Book of Hours of Isabeau of Bavaria, second half of the fourteenth century

Christ Struck across the Face

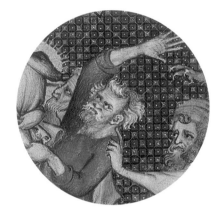

The guards set themselves against Jesus, whom they have just arrested. A judge (perhaps Pilate), seated on a bench, makes a slight gesture to calm his henchman, who seizes Jesus' tunic and, encouraged by a fiendish creature, prepares to strike Jesus savagely.

He is not the only one in a frenzy. A gesticulating crowd, arms raised, faces mocking and threatening, encircles Jesus. Standing, haloed, with eyes closed beneath his hood and hands crossed freely, Jesus does not respond to either the sarcasm or the blows.

This dramatic image of extraordinary violence is attributed to illuminator Jean Le Noir,* who was trained by Jean Pucelle.*

62

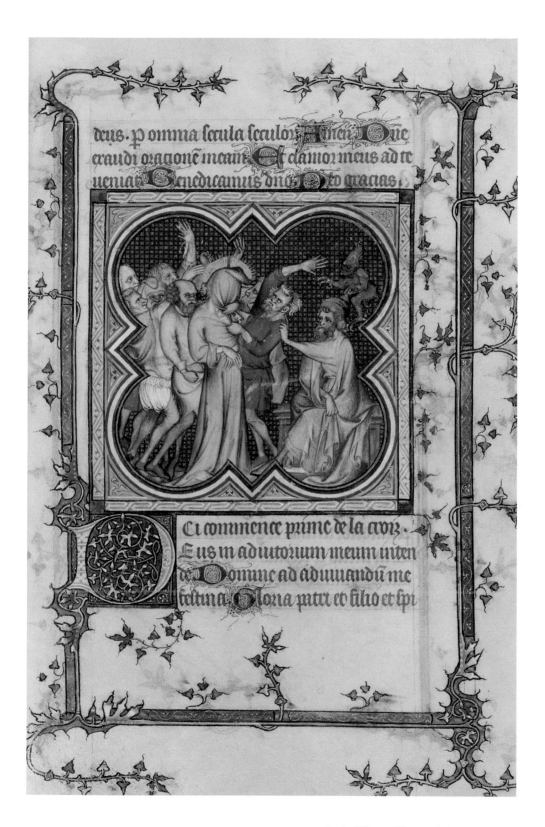

The Crucifixion

*But after they were come to Jesus,
when they saw that he was already
dead, they did not break his legs.
But one of the soldiers with a spear
opened his side: and immediately
there came out blood and water. . . .
For these things were done that the
scripture might be fulfilled.*

The Gospel according to Saint John 19:33–37

Pilate did not free Jesus. The crowd cried, "Crucify him!" On the hill called Golgotha, it is dark in the middle of the day. And at the ninth hour, Jesus expired. The Virgin and the apostle John are not yet aware of his death. They beg the soldiers not to break his legs, as they have just done to the two thieves.

The shadows, saturated with mourning angels, emphasize the whiteness of the tortured bodies. Two furious battles are taking place. On one side, Saint Michael slays the demon and seizes the soul of the good thief, while, on the other side, the soul of the bad thief falls prey to the devil.

In the lower register,* the confused melee of steeds and multicolored costumes expresses the fright that comes over the horsemen, "having seen the earthquake and the things that were done" (Matthew 27:54).

This work by the subtle and powerful brush of the Rohan Master* is undoubtedly one of the most beautiful pages in the French art of the miniature.

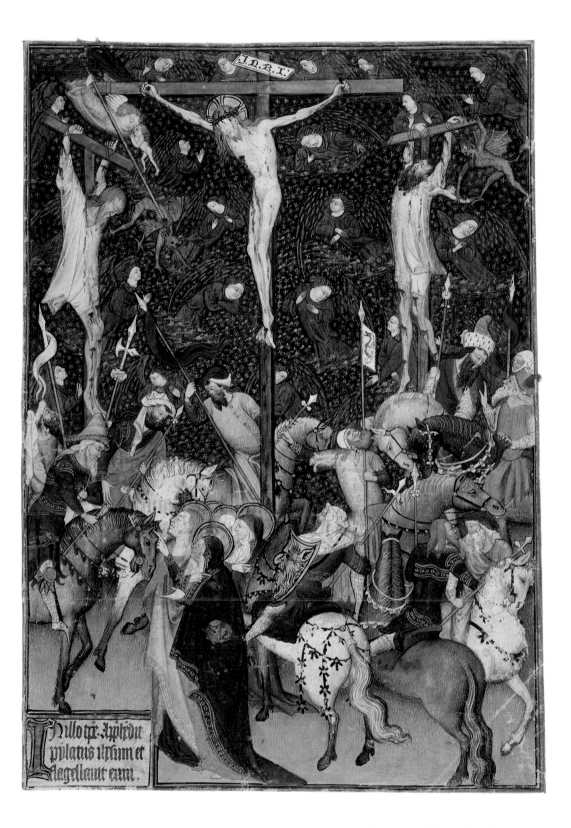

Rohan Book of Hours, fifteenth century

The Resurrection

Three days after the Crucifixion, Christ arose from the tomb, conquering death. Dressed in a crimson mantle, he wears a crown of thorns and exposes his wounds. With a sign of benediction, he plants in the ground the triumphal cross, which meets the sky and the divine rays.

A dozing guard, his weapon in hand, has his back to the tomb and sees nothing. But the other two, wearing iron breastplates, are blinded by the apparition and the supernatural light. Seized with fright, they raise their arms as if to protect themselves.

In the margins, at the bottom, a piper dances among the leaves and flowers. A bit higher and to the left, a couple walks away. We see them from the back, arm in arm. The lady wears a hennin and a dress with a long train. At the top, in black tights and an ermine collar, is a strange figure with a feline head—an evil-eyed devil.

66

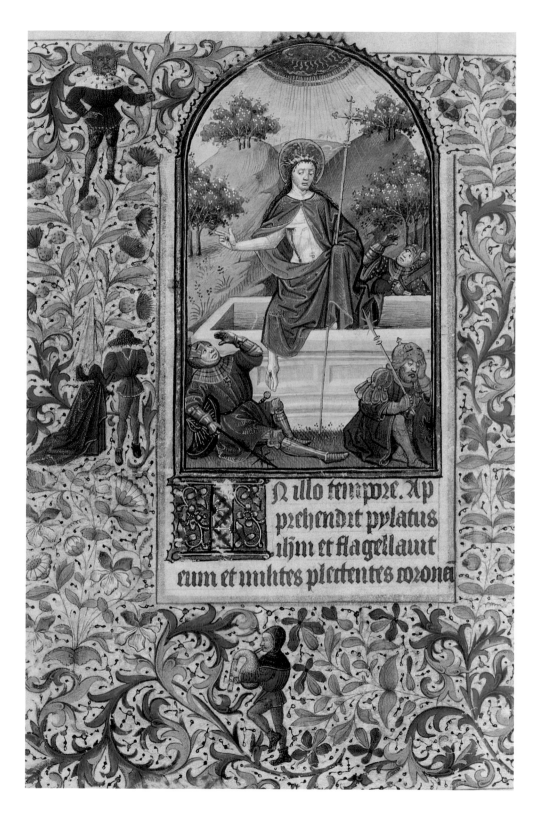

N illo tempore. Ap
prehendit pylatus
ihm et flagellauit
eum et milites plectentes coronam

Pietà

Blessed son, charming son, loved son,
Virtue-driven, gracious son,
Of all the living, most perfect one,
O beauty pure,
Choice of humans, flower of nature,
Priceless jewel, perfect portraiture,
Eye so gentle, most benign stature,
Holy face,
Love-kindled, adorable face,
Alas! now its former grace,
Disfigured, bloody, in its place!

Arnoul Gréban, "Mystery of the Passion,"
ca. 1450

Image of piety par excellence, the Virgin of Mercy encouraged Christians of the Middle Ages to meditate on the suffering of Christ. The miniature offers, for their compassion, the tortured body of Jesus, resting on his mother's lap, head thrown back and eyes closed. His swollen left hand rests on Mary's arm. The right hand, bearing the stigmata, hides his thinly veiled nudity. Blood still runs down his leg from the wound in his side. Seated on her throne, a tearful Mary caresses her sacrificed, beloved son with infinite tenderness. A kneeling angel gently endeavors to remove Christ's long hair from the crown of thorns; another angel delicately wipes his wounds with a white cloth. In reverence, the two angels behind the Virgin's throne do not dare to approach or touch the body of Christ. Mary, in a blue veil and golden halo, is surmounted by two blue seraphim on an ultramarine background, strewn with the acronym IHS.*

Under the Pietà, the white letter R (for Richard) and the vermilion letter M (for Marguerite) are joined by a bond in the initial of the prayer to the Virgin, "O intemerata."*

The frame is entirely secular. At the top, a man kneels in a nest of greenery. Opposite, an owl—a symbol of death—is surrounded by a host of birds in a dead tree. Everywhere else, there are all sorts of animals, including birds, butterflies, and snails, amid flowers of every possible color.

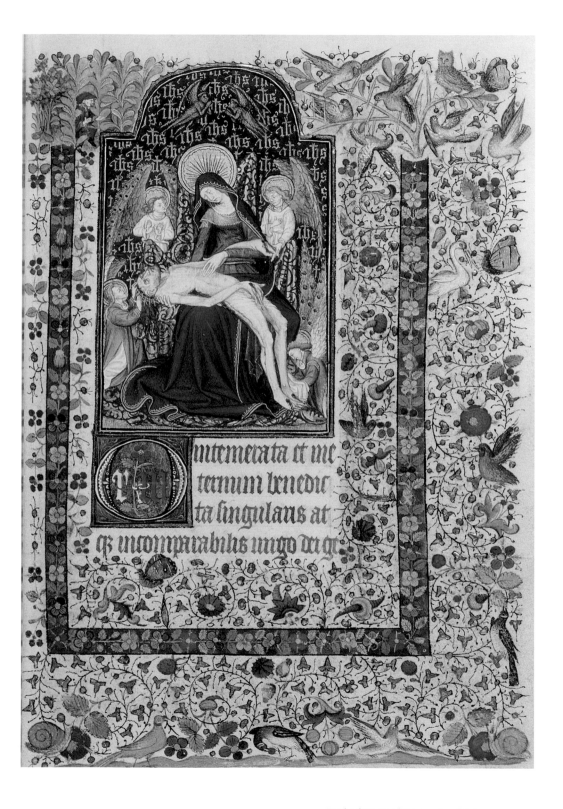

Book of Hours of Marguerite of Orleans, ca. 1430

Christis of Mercy

*Just Father, the world hath not known
thee: but I have known thee. And these
have known that thou hast sent me.
And I have made known thy name to them
and will make it known: that the love
wherewith thou hast loved me may be
in them, and I in them.*

Jesus' prayer,
The Gospel according to Saint John 17:25–26

This scene expresses all the compassion of the angels, who, behind an opulent curtain, support and surround the body of Christ, descended from the cross. His head, with its crown of thorns, falls onto his shoulder. His chest and arms are atrociously lacerated. Blood still runs from his side.

On either side of the cross are the instruments of the Passion—whips and the flagellation column, the lance, and the vinegar-soaked sponge.

Where the initial would normally be, under the image of devotion, Lady Marguerite de Beauvilliers meditates in her oratory before the suffering of Christ the Redeemer.

At the extreme left, a caterpillar of thorns or a bramble branch leads to the lower register. There, before a marveling John the Baptist, Christ the Savior resurrects the first of the just, Adam and Eve. The damned will remain imprisoned by flames and devils in the maw of the monster of hell. Once again, a small owl evokes death, while three angels pray in the margins.

Prayers of the Passion

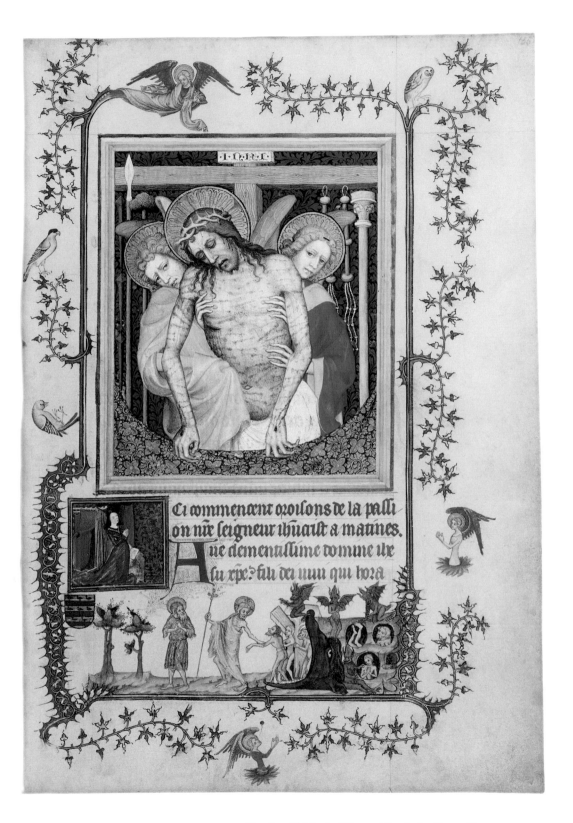

Very Beautiful Book of Hours of Our Lady of Jean of Berry, ca. 1404

The Dove of the Holy Spirit

I saw the Spirit coming down, as a dove from heaven; and he remained upon him.

The Gospel according to Saint John 1:32

The Hours of the Holy Spirit evoke episodes from the life of Jesus where the presence of God is manifested to everyone. Here, in the form of a dove, the Holy Spirit descends into the world. The nimbus* marked with the cross of Christ haloes its head. The rays from the gold disk, representing God, creator of all things, fill the sky and the page. Thus, the artist gives us an extraordinarily simple and strong image of the Trinity.

Hours of the Holy Spirit

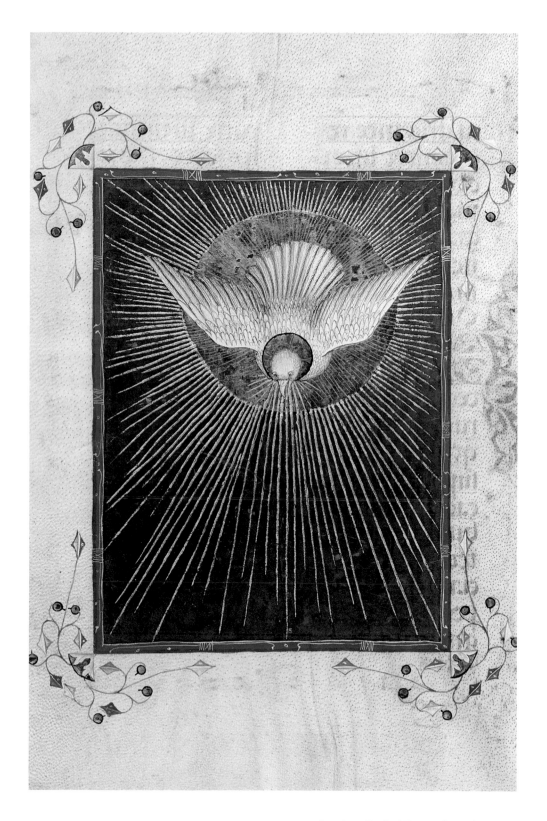

Franciscan Book of Hours and Missal, ca. 1380

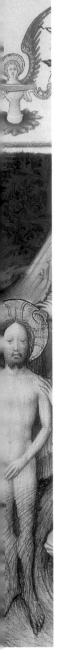

The Baptism of Jesus

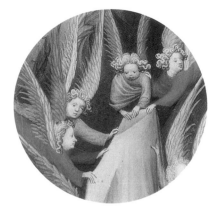

Then cometh Jesus from Galilee to the Jordan, unto John, to be baptized by him.

But John stayed him, saying: I ought to be baptized by thee, and comest thou to me?

And Jesus answering, said to him: Suffer it to be so now. For so it becometh us to fulfill all justice. Then he suffered him.

The Gospel according to Saint Matthew 3:13–15

During the baptism of Jesus, the Holy Spirit manifested itself in the form of a dove and a voice from heaven. This is a frontal view of a solemn Jesus, standing naked in the river Jordan. His right hand is raised in a sign of benediction, while the left hides his nudity. John the Baptist, kneeling on the bank, leans on Jesus' shoulder. He pours the baptismal water from a gold vase. A mantle of red—the color of martyrs—covers his habitual camel hair garment.

Angels present Jesus with an ample pink tunic. Their wings raised toward heaven form a surprising ballet before a strange mountainous landscape. God the Father appears on a red sun in the middle of an intensely blue sky. Wearing a diadem, he holds the globe in one hand and, with the other, blesses Jesus, his beloved Son. The dove of the Holy Spirit, absent from this image, descends onto the saint depicted in the initial D of the prayer "Domine labia mea" (Open my lips, O Lord, that my mouth may proclaim thy praise) (Psalms 51:17).

At the bottom, in the frieze, a priest welcomes a newborn he will baptize and the procession of his relatives reciting the rosary.

In the margins, three birds—a crane, a goldfinch, and an owl—counterbalance four musician angels with red, gold, and blue wings, as in the miniature.

Hours of the Holy Spirit

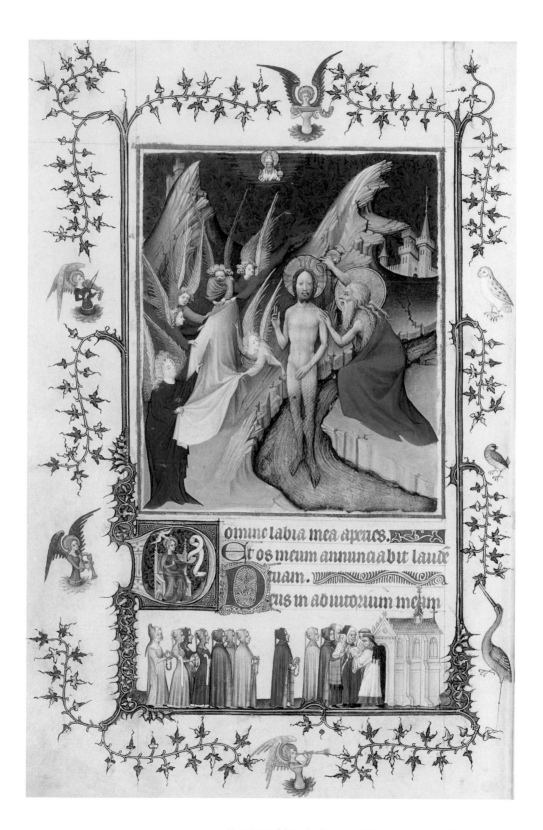

Very Beautiful Book of Hours of Our Lady of Jean of Berry, ca. 1404

Christial in Limbo

Now when we were together with all our fathers in the depth of the darkness of death, we were suddenly enveloped in a light golden like the sun and a gleam illuminated us. And immediately Adam, the father of the entire human race, quivered with joy. . . . Then did the Lord in his majesty, trampling death beneath his feet, deprived hell of all its power and drew Adam unto brightness of the light.

Apocryphal Gospel of Nicodemus

Superbly haloed under the divine rays, Christ the Savior drives the shaft of his standard into the maw of the monster. Toward him he pulls Adam, the first to descend into hell after expulsion from the Garden of Eden and after living for 120 years. Behind him, Eve and the prophets hold out their hands in turn to the Redeemer.

Modestly placed in the outer margin of one page of the *Rohan Book of Hours*,* this naive and charming image was not the work of the master, but of one of his apprentices, who gave free rein to his imagination.

Hours of the Holy Spirit

aque que supcr celos sunt lau
dent nomen domini

Quia ipse dixit et facta sunt
et ipe mandauit et creata sunt.

Statuit ea in eternum et in secu
lum seculi: preceptum posuit z no
preterabit

Laudate dnm de tra draconies
et omnes abyssi

Ignis grando nix glacies spi
ritus procellarum que faciunt u
bum eius

Montes et omnes colles ligna
fructifera et omnes cedri

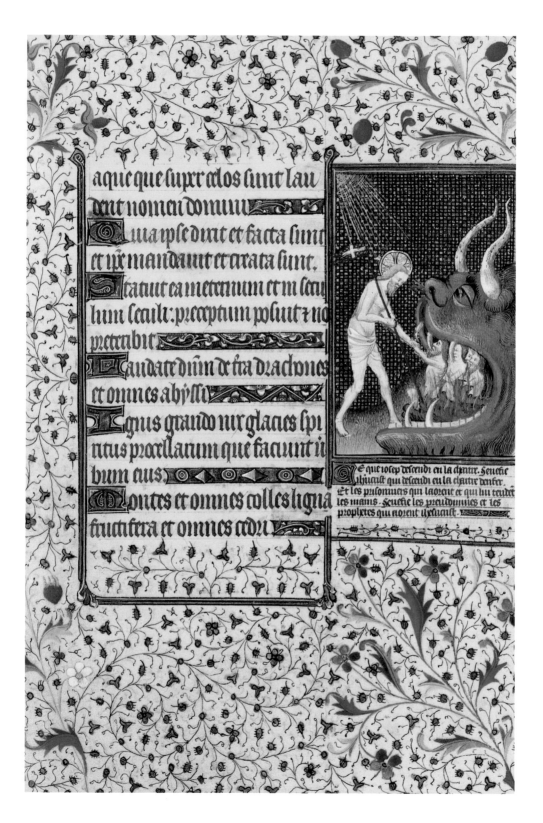

Ce que ioseph descendi en la chartir. Seuethe
silhueist qui descendi en la chartre dender.
et les pusonniers qui laorent et qui lui tendet
les mains. Seuethe les preudomnies et les
propletes qui norent il seruist.

Rohan Book of Hours, fifteenth century

Jeanne of Navarre Praying

The cycle of the Hours of the Trinity is introduced by a small kneeling queen. Jeanne of Navarre,* crowned, yet modest, is praying. Mary tilts her head and holds the baby Jesus, who puts his arms around her neck. Cheek to cheek, the young Virgin and child form an image of ineffable tenderness. The graceful scene is painted inside the initial, on a sparkling azure checkerboard.

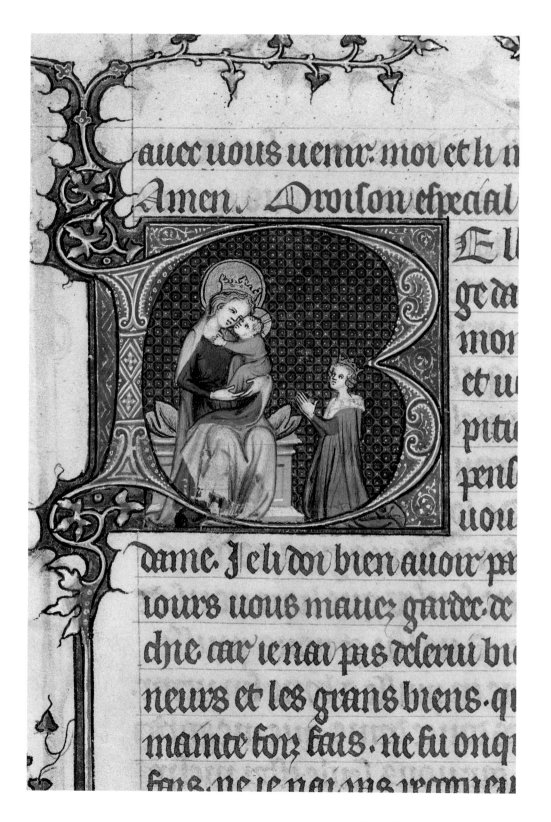

auec uous uentr. moi et li n
Amen. Oroison especial
E ll
ge da
mor
et u
pitu
penc
uou
dame. Jeli doi bien auoir p
tours uous maue; gardee de
dne car ie nai pas deserui bi
neurs et les grans biens. q
mainte bor fais. ne fu onq
fars. ne ie nai pas remeu

The Trinity

God the Father, you who were ne'er begot,
you, your only Son,
you, comforting Holy Spirit,
o holy and indivisible Trinity,
we adore you with all our heart,
we praise you and bless you.

Tract from the Mass of the Trinity

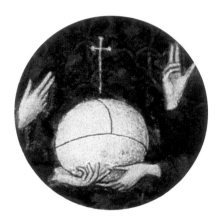

Both haloed, barefoot, and dressed in blue, Father and Son look alike, feature for feature, and together carry the globe and cross.

The Father, who seems slightly older, raises his right hand to the Holy Spirit, while the Son points to his cross.

In this highly austere image, the dove of the Holy Spirit completes the triangle and the mystery of the Trinity.

Hours of the Trinity

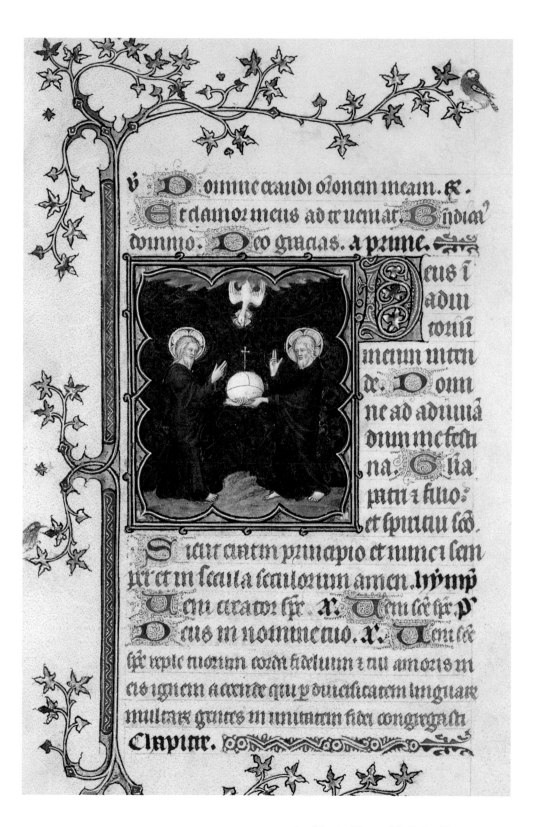

The Trinity: God the Father Welcoming Christ on the Cross

Abba, Father, all things are possible to thee: remove this chalice from me; but not what I will, but what thou wilt.

The Gospel according to Saint Mark 14:36

God the Father welcomes his crucified Son, whom he blesses with one hand, while he attempts to wipe the blood on his side with the other.

The contrast is striking: at left, the sovereign Father is enthroned on a rainbow. His feet rest on the globe, divided into the three continents that were known at the time. His brow is encircled by the triple diadem atop a resplendent halo, and he is clothed in an ample and lavish amaranthine mantle. Opposite is the poor tortured body of Christ, whose halo is barely distinguishable from the wood of the cross. But the dove of the Holy Spirit connects the all-powerful Father and the suffering Son, and expresses the compassion of love within the Trinity.

The scene is depicted between two tapestries. On the one in the background, held up by celestial angels, appear the words spoken to God the Father by Christ during his Agony in the Garden of Gethsemane, "What thou wilt."

The words are repeated on the tapestry in the foreground, held up by two angels in more terrestrial livery, surrounding the coat of arms of the pious Marshal of Boucicaut. He "without fail, said his hours and many an orison and the Suffrage of the Saints," and, they say, took them as his device before embarking on a difficult battle.

82

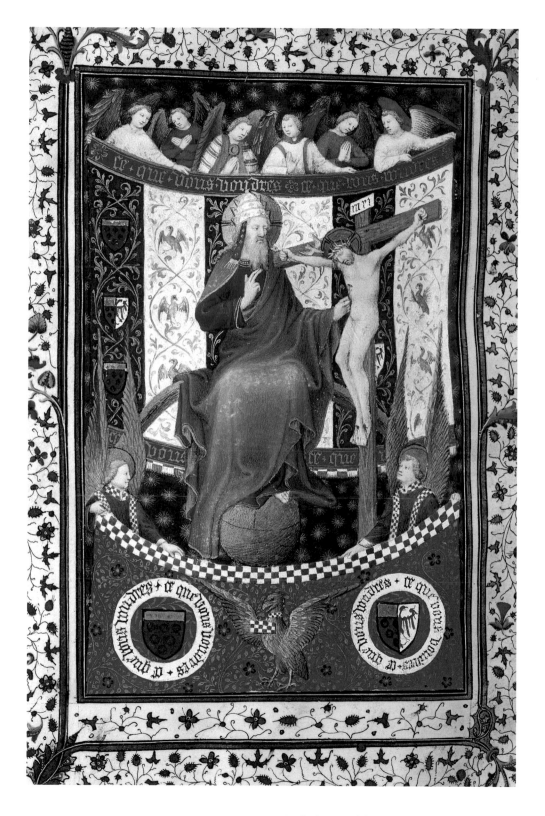

Book of Hours of the Marshal of Boucicaut, ca. 1405–8

Patron before the Madonna

*We fly to your patronage, O holy
Mother of God; despise not our
petitions in our necessities; but
deliver us from all dangers, O glori-
ous and blessed Virgin.*

Second Vespers of Our Lady of Consolation

Kneeling in the green grass, a young abbot in a black hooded robe prays
to the Madonna before the start of the Office of the Dead.

The crowned Virgin is enthroned in the midst of a cloud of angels
and shows him the God-child, who bends down to give the abbott his
benediction.

In the flowered borders are the usual winged creatures—bird, peacock,
and butterfly.

Less commonly, the bird holds in its beak the patron's coat of arms.
Stranger still, Master Fox, dressed as a Benedictine monk, preaches to his
flock, represented by three geese, who listen quietly.

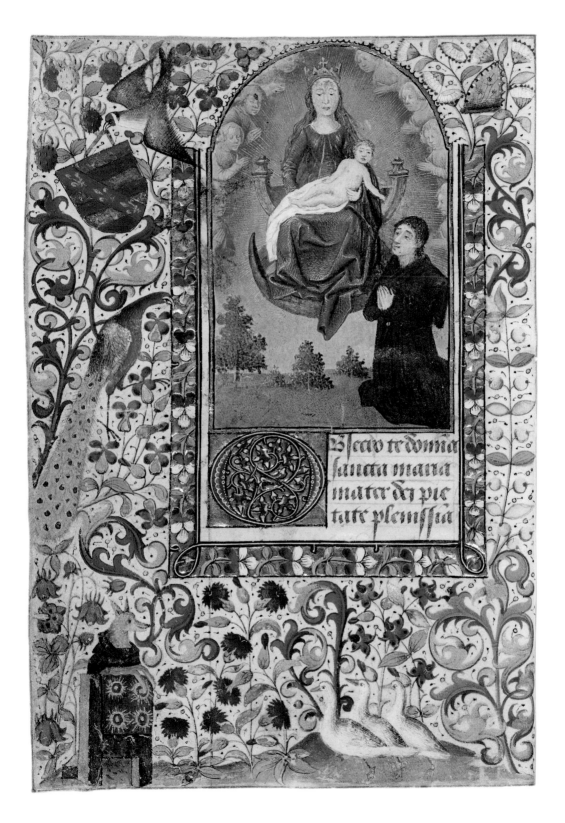

Rivoire Book of Hours, ca. 1465–70

Office of the Dead

And we will not have you ignorant brethren, concerning them that are asleep, that you be not sorrowful, even as others who have no hope.
For if we believe that Jesus died and rose again: even so them who have slept through Jesus, will God bring with him.

First Epistle of Saint Paul to the Thessalonians
4:12-13

A blazing chapel with the coat of arms of the Duke of Berry has been erected in the middle of the church, behind the altar that we note at the right. An opulent brocade sheet covers the coffin of the deceased, set under a canopy where several rows of candles burn. A standing monk, breviary* in hand, recites the Office of the Dead. On either side of the catafalque, six Dominicans seated on austere wooden benches, feet near foot warmers, follow the ceremony. Strangely, their expressions seem to convey more worry than sadness.

In the doorway, a hooded lady wearing mourning dress joins the four lamenters seated behind the mendicant monks.

In the initial of the text that follows, two men are seated face to face. One of them seems to be showing his neighbor the page containing the Office of the Dead.

At the bottom of the miniature, in the lower register, the procession goes to the cemetery after the church service. Behind the cross and the alb-clad servers, a priest in ceremonial mantle and two young laymen bearing torches precede the lamenters, who carry the catafalque in front of the friends and relatives. This faithful and contemplative image of the Office of the Dead is traditionally surrounded by three birds, including an owl, and three angels, who, in this case, toll the knell.

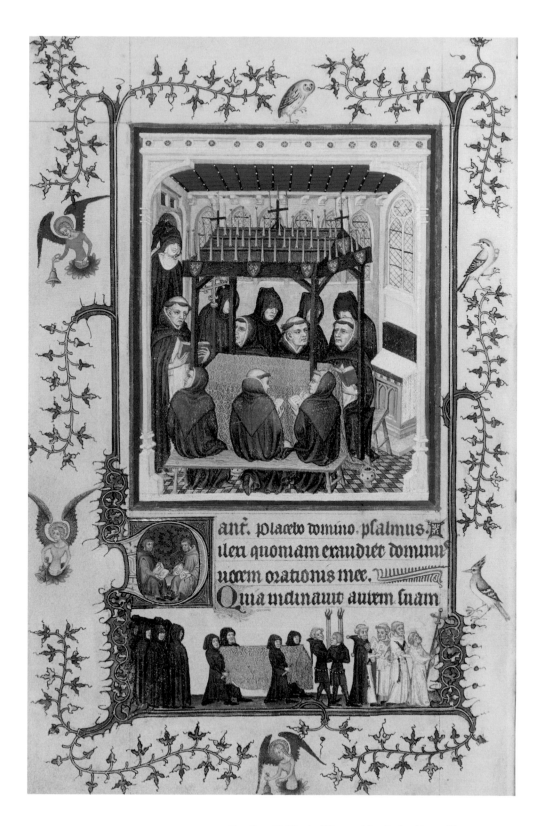

Very Beautiful Book of Hours of Our Lady of Jean of Berry, ca. 1404

The Burial

*Grant eternal rest unto them, O Lord,
and let perpetual light shine upon
them that they may rest in peace.
Amen.*

Prayer from the Mass of the Dead

In a cloister in the middle of the city, two laymen lay the body of the deceased, wrapped in a traditional white shroud, directly in the ground. At the edge of the freshly dug grave, a shovel lies next to bones they dug up.

The priest in a gold cope sprinkles the body with holy water, using the sprinkler that he has just dipped in a bucket. The altar boy, wearing a white alb, carries a cross along with the bucket. Three black-clad lamenters and two figures in the doorway attend the burial.

Under the miniature, the colored initial extends into the margins as flourishes of foliage and single leaves.

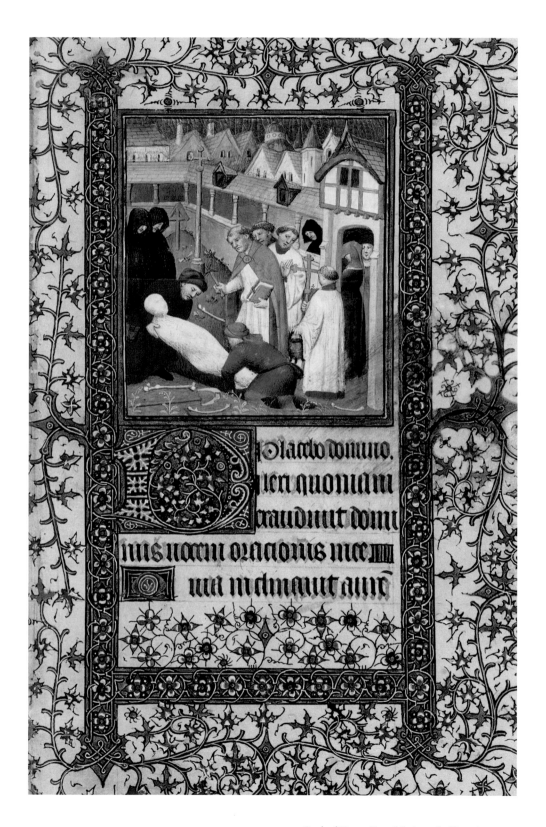

Book of Hours, Use of Paris, early fifteenth century

Job on His Dung Heap, Ridiculed by His Friends

*Who will grant me that my words may be
 written? Who will grant me that they
 may be marked down in a book?*
*With an iron pen and in a plate of lead, or
 else be graven with an instrument in
 flint stone?*
*For I know that my Redeemer liveth, and
 in the last day I shall rise out of the
 earth.*
*And I shall be clothed again with my skin,
 and in my flesh I shall see my God.*

Job 19:23–26

Provided for meditation by the sick and dying, the image of Job's suffering often appears at the beginning of the Office of the Dead.

The devil wanted to prove to God that Job, a just and pious man, would not remain faithful to God if he deprived him of his wealth and health. So here he is, tested by Satan, alone and miserable on a dung heap. Job has a clear conscience, but his friends are convinced that his misfortunes are the consequence of an unavowed sin.

One lifts up his mantle to prevent it from being soiled, revealing his immaculate foot next to the squalid feet of Job. Another emphasizes his words by gesticulating with both hands. The third listens ingratiatingly. Job's distress at his friends' total lack of comprehension is immense.

The painter, Jean Fouquet, places the scene in front of a contemporary setting, the keep of the royal castle of Vincennes, where Charles VII resided at the time.

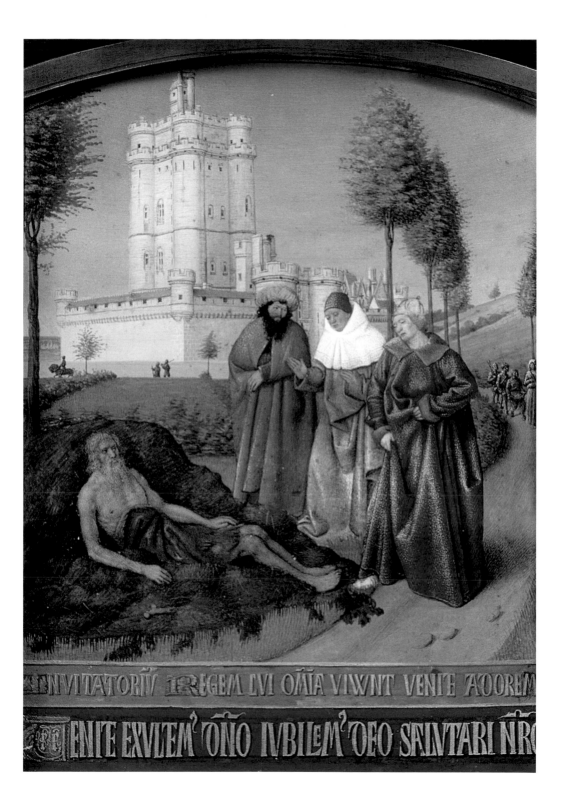

Jean Fouquet, *Book of Hours of Étienne Chevalier*, ca. 1455

Louis de Laval Praying

You alone Lord are my salvation.

Latin prayer at the top of the miniature

Louis de Laval addresses his prayers to the Virgin and child, not visible here, but depicted on the left-hand page of the manuscript.

Louis de Laval, Lord of Châtillon, eminent adviser to Louis XI, was a rich and powerful noble. Here he is dressed in a lavish red robe and a necklace adorned with the Order of Saint Michael.

His coat of arms is woven into the velvet covering the table before him.

He is an old man. This portrait was painted a few years before his death in 1489. He is also a pious man, depicted kneeling before his open prayer book.

The dignity of his bearing helps reinforce the expression of solemnity and ardor evident on his face.

At the back of the room, at a respectful distance from their lord, an assembly of black-capped clerics participates in the meditation. Two small black and white dogs add the sole slight touch of whimsy.

92

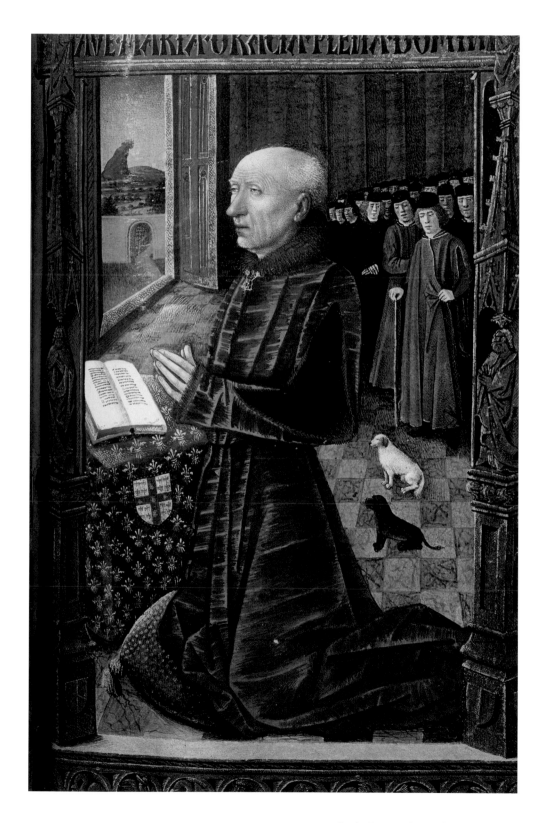

The Nativity of John the Baptist

Now Elizabeth's full time of being
delivered was come: and she
brought forth a son.
And her neighbors and kinsfolk heard
that the Lord had shewed his great
mercy towards her: and they con-
gratulated with her.

The Gospel according to Saint Luke 1:57–58

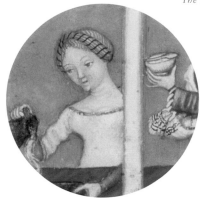

The life and death of John the Baptist are depicted here in two pages, with his birth first. John the Baptist arrives in the world dressed in a tiny hair shirt. In actuality, he would not wear one until much later, in the desert. But the idea is a charming one and immediately identifies the haloed newborn. Mary, his mother's cousin, kneels, ready to swaddle him. Suddenly, she releases the swaddling clothes when she sees the infant raise his tiny arm in a gesture of benediction. His mother, Elizabeth, keeps her eyes fixedly on them. Three servants enter the room. The first, in a pretty, low-cut dress, delicately pours water onto Elizabeth's hands, while firmly holding the basin. The second, in a high-necked dress, brings a bowl of broth and a spoon. The last and youngest, hair unbound, walks through the door with some poultry and two plates.

The artist has painted a rich and noble house—an Italian villa with marble columns and arches. Two precious hangings adorn the canopy bed. The ocher walls are painted with tempera. Do you see the lemon tree in the courtyard to the right? A long gallery runs beneath the roof and reveals a narrow line of blue sky on a background of golden stars.

94

Franciscan Book of Hours and Missal, ca. 1380

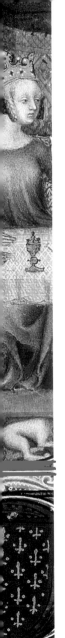

The Dance of Salome

On Herod's birthday, the daughter of
 Herodias danced before them: and
 pleased Herod.
Whereupon he promised with an oath, to
 give her whatsoever she would ask of
 him.
But she being instructed before by her
 mother, said: Give me here in a dish the
 head of John the Baptist.
And the king was struck sad: yet because of
 his oath, and for them that sat with him
 at table, he commanded it to be given.
And he sent, and beheaded John in the
 prison.

The Gospel according to Saint Matthew 14:6–10

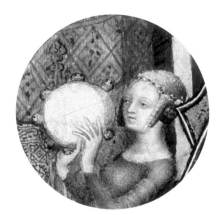

King Herod had John the Baptist arrested for criticizing him for taking his brother's wife, Herodias. Here Herod celebrates his birthday with splendor. Herodias is enthroned beside him. The banquet table is set with gold dishes. Salome dances before the king. She raises the tambourine with which she sets the rhythm for her feet. Herod, enchanted, cannot take his eyes off her. He even forgets to throw the bone he is holding in his hand to the little dog waiting impatiently at his feet. Herodias, who has organized the party, hand raised, is actually the one who decides the fate of John the Baptist.

In the initial, the coat of arms of the Duke of Berry, who commissioned this Book of Hours, is a reminder that John the Baptist was his patron saint.

Graceful birds, perched on delicate branches, adorn the margins.

96

Lady before the Madonna

Behold I will send my angel, who shall go
before thee, and keep thee in thy journey,
and bring thee into the place that I have
prepared.
Take notice of him, and hear his voice.

Exodus 23:20–21

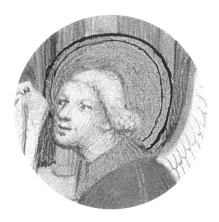

The guardian angel of an anonymous patron sponsors the Suffrage of the Saints,* collected at the end of the Book of Hours.

The richly dressed noble lady, wearing a hennin, hands pressed together, kneeling on a soft cushion, is supported by her guardian angel. She scarcely dares raise her eyes to the Madonna, who tenderly welcomes her. The Virgin leans toward the woman with a graceful motion, and the child momentarily turns away from his mother's breast to bless the lady with a gentle gesture of his hand.

Divine rays light the fine-columned loggia, which opens onto greenery beneath a dark sky.

The small, square, delicately colored painting is surrounded by grape leaves and flowers.

Suffrage of the Saints

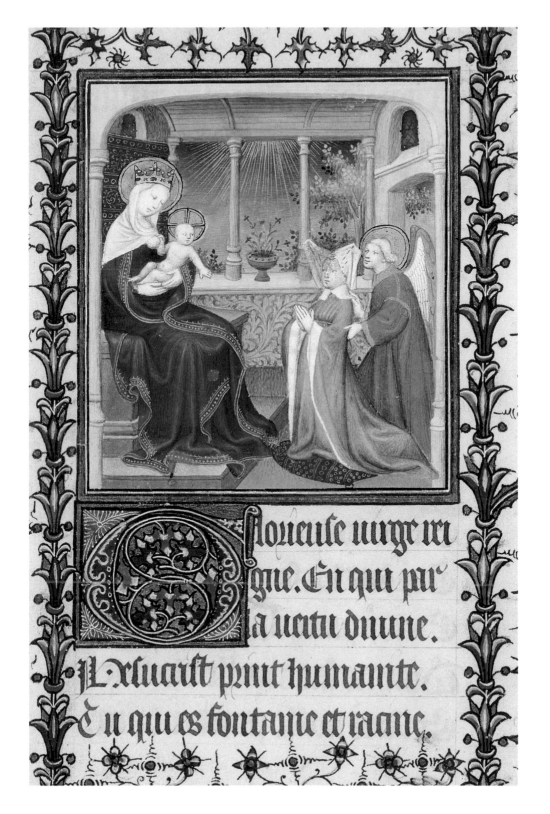

loneule uirge rei
gnie. En qui par
la uertu diuine.

A'xluaiff print humaine.
Cu qui es fontaine et racine.

Book of Hours, Use of Paris, early fifteenth century

Saint Anne and the Three Marys

Outside the city, at the intersection of two arbor-covered paths, Anne presides over an encounter with her daughter Mary and Mary's divine son.

All converge on the haloed Virgin, who stands motionless as a statue, eyes downcast, to present the baby Jesus.

Behind them, we glimpse Joseph, the only man present, approaching in the shadows. On the other side, Anne's two other daughters, also named Mary, are depicted. One, the wife of Alpheus, has four sons—James the Less, Joseph the Just, Simon, and Jude. The other, Mary-Salome, wife of Zebedee, is the mother of James the Great and John the Evangelist.

Jesus blesses Saint Anne, who crosses her hands on her fertile belly.

The mothers watch over their children. James shows his brother, John, how to pray, while another child hides in his mother's veils.

Under the lions of Judah,* two savages curiously hide their nudity behind the coat of arms of Étienne Chevalier.

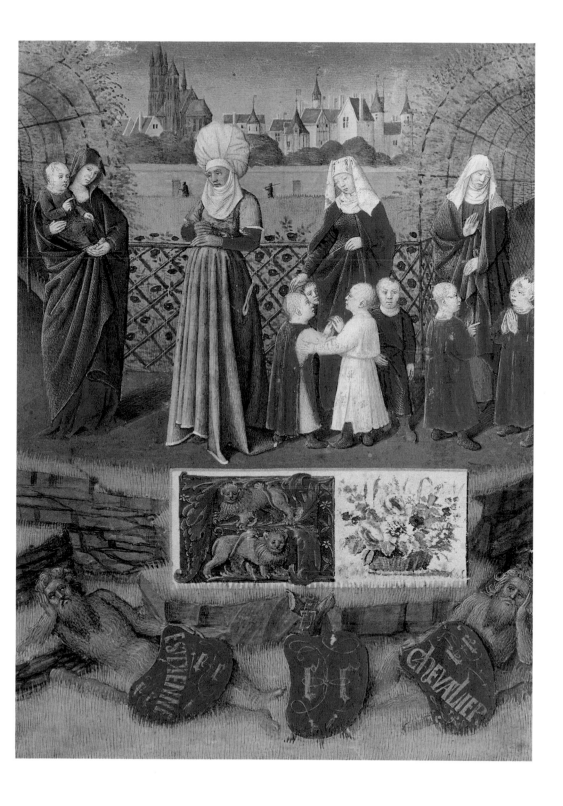

Jean Fouquet, *Book of Hours of Étienne Chevalier*, ca. 1455

Saint John the Baptist

The bed curtain has been tied back so that relatives and neighbors can witness the miracle announced to Mary by the angel Gabriel (Luke 1:36).

Elizabeth still seems amazed under the sheet adjusted by the midwife. Zacharias, struck mute for disbelieving the astounding news, responds to the question asked by the visitors by writing on a tablet, "His name is John."

On the Virgin's lap, the newborn, with a delicate nimbus, awaits the bath being prepared for him by a robust servant. An elegant young woman warms the child's swaddling clothes by the hearth while watching the water being poured.

The immaculate whiteness of the curtains and sheets emphasizes the opulent reds and blues of the garments.

In the lower register, spilling over onto the floor of the room, is the coat of arms of Étienne Chevalier, treasurer of France, the patron of this Book of Hours. It sits side by side with the lamb, who is surrounded by a crown of flowers and illustrates the words of John, "Behold the lamb of God."

Finally, at the very bottom, two green-winged angels present carved wooden bas-reliefs. These evoke three episodes from the life of the saint: the desert hermit responding to all those who came to be baptized by him, the baptism of Christ, and the death of John the Baptist requested by Salome.

Suffrage of the Saints

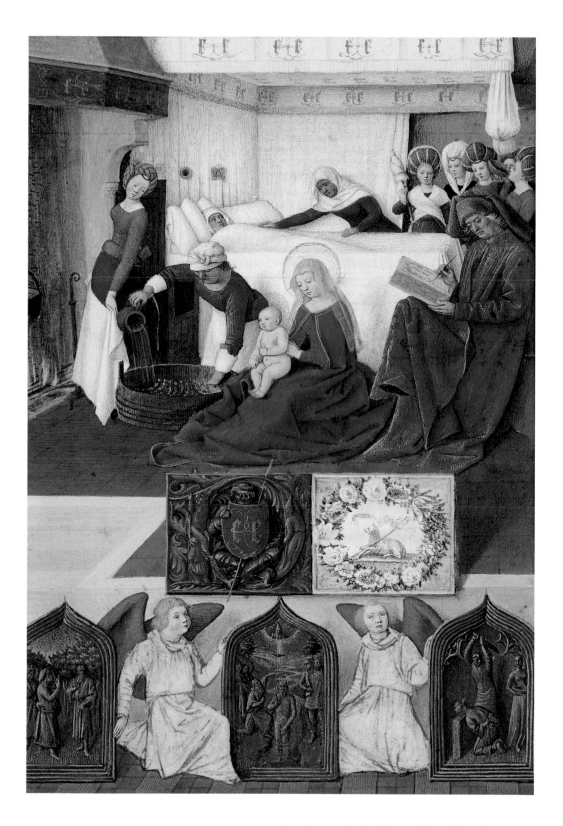

Jean Fouquet, *Book of Hours of Étienne Chevalier*, ca. 1455

Saint James the Great

Elder brother of John and son of Zebedee, fisherman on the Sea of Galilee, James was part of the first circle of disciples. The apostle was present at the Transfiguration and the Agony of Jesus at the Mount of Olives. After the Ascension of Christ, James preached Jesus' teachings, first in Judea, and then, for several years, in Spain. On James's return to Jerusalem, Herod Agrippa sentenced him to death and had him decapitated. According to legend, his body was placed on a ship and guided by angels to Galicia, where his cult immediately took on extraordinary proportions.

Pilgrims flocked from all over Europe to Santiago de Compostela and gathered around his tomb, then in the immense basilica built by the Catholic kings.

Thick-bearded and barefooted, the saint on this page, with a shell on his hat and a long pilgrim's staff in hand, bears the attributes of a Saint James pilgrim. The Holy Scriptures, which he holds under his arm, bear witness to his role as a missionary to the green land of Galicia, bordered by waves of the sea. All of this stands out against a backdrop composed of the coat of arms of the Marshal of Boucicaut and his device, "What thou wilt."

104

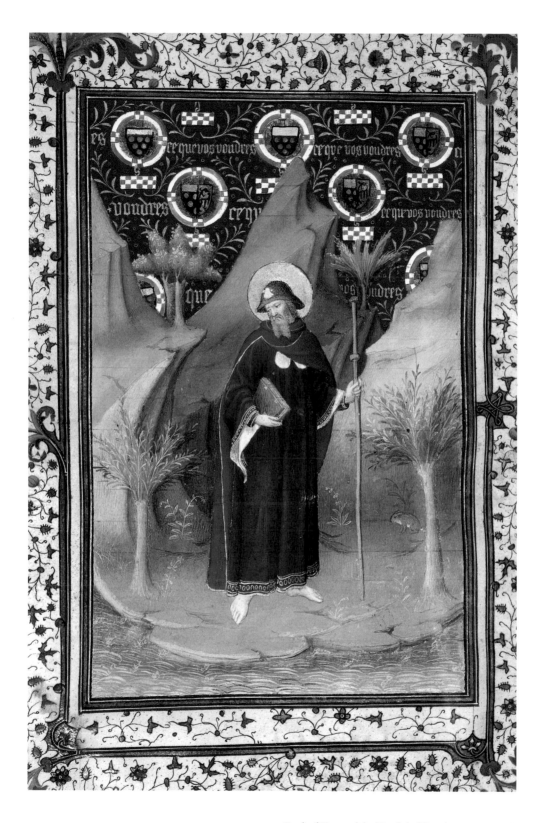

Book of Hours of the Marshal of Boucicaut, ca. 1405–8

Saint Anthony the Great

It is most often at night in the desert that demons come to torment Saint
Anthony. Here, the artist, from the studio of Jean Colombe, takes a much
more audacious and realistic approach. He locates the scene in what was,
for him, the contemporary decor of a bedroom in a French castle, whose
high casement window lets in the pale twilight.

At right, a seductive young woman, barefoot and lightly dressed, with
hair unbound, arches her pretty waist between the saint, to whom she beck-
ons, and the bed, which she turns down. The two small horns on the top of
her head reveal her diabolical nature.

At left, white-bearded Anthony, in a homespun robe, remains stoic. He
is painted on the hearth flames. They symbolize "Saint Anthony's fire," or
the skin disease shingles, which he customarily heals. He resists the lure, if
not with his heart, at least with his hand. A ballet of quite insolent cherubs
frames the scene.

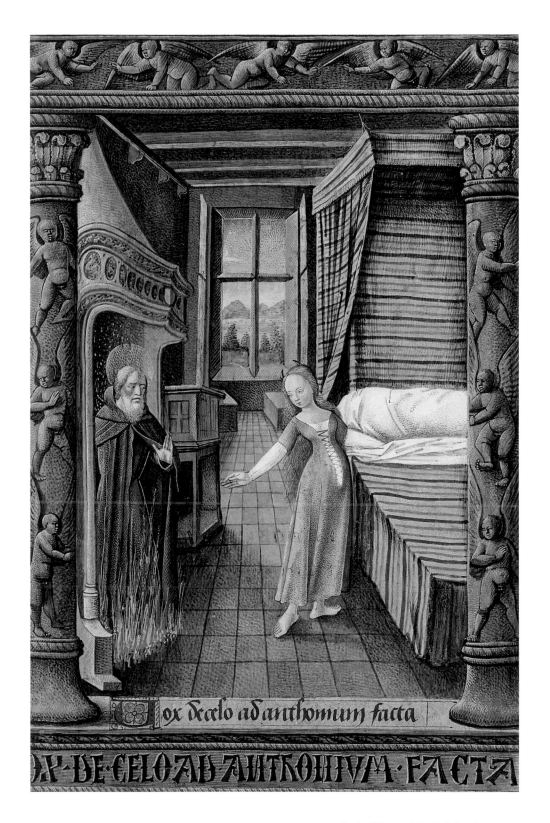

ox de celo ad anthonium facta

OX·DE·CELO·AD·ANTHONIVM·FACTA

Saint Leonard

Legend has it that Saint Leonard received his baptism at the hands of the archbishop of Reims, Saint Rémi, in the year 500. Having become an abbot and an intimate of the king, Leonard obtained royal permission to pardon all prisoners whom he visited. He later became a hermit. It was sufficient, so they say, for captives to invoke his name from their prisons to regain their freedom. Tradition adds that, once freed, these men presented to Saint Leonard the irons with which they had been bound.

The Boucicaut Master* depicts the saint at the door of his oratory in the forest to which he had retired, symbolized by the two trees. He holds in his hand the chains of two prisoners, "all naked save their small loincloths," who implore him on their knees.

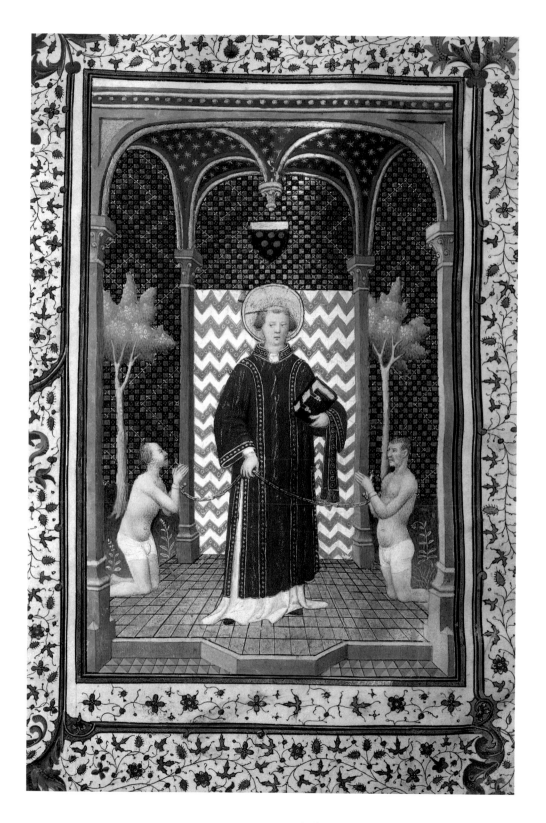

Book of Hours of the Marshal of Boucicaut, ca. 1405–8

Saint Margaret

Saint Denis, Saint George, Saint Blaise,
Saint Christopher and likewise Saint
* Giles,*
Saint Catherine, let us not forget . . .
Saint Barbara and Saint Margaret,
Remember me always in my trials,
As if it were your own volition.
May God through you hear the plea
Of all petitioners whomever they be,
Made with good heart and honest
* praise,*
Whatever perils them beset.
Then God shall grant them their
* petition.*

Eustache Deschamps, 1407

Safe and sound, Margaret comes out of the back of the dreadful dragon that had just eaten her. She holds in her hands the small gold cross with which she escaped from the entrails of the bleeding monster by perforating its dorsal spine. The demon turns around, a scrap of her robe still in its maw, to stare in amazement at the young virgin whom he thought he had devoured.

110

Margaret was attacked by the dragon in the prison where Olibrius, the prefect of Antioch, had thrown her after she rejected him.

But it is below the stained-glass windows of a superb Gothic cathedral, with walls hung with red tapestries, that the artist depicts her.

The story continues—or rather is presaged—in the small medallion below the main image. The saint plies her distaff while guarding her sheep as Olibrius approaches, soon to be charmed by her beauty. In the borders, in the midst of daisies, cornflowers, and strawberries, there is a snail, a hoopoe, a pair of pheasants, a pair of monkeys, and, as is often the case, a peacock.

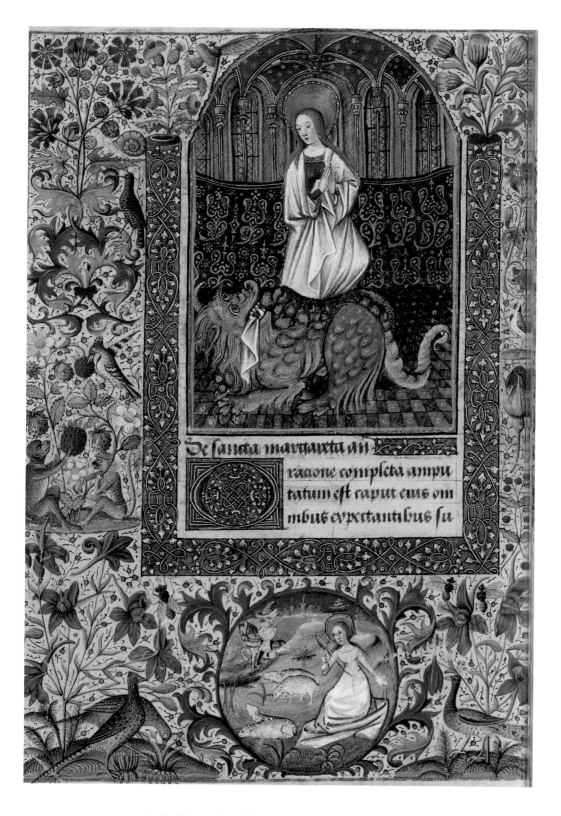

De sancta margareta an
raaone completa ampu
tatum est caput eius om
mbus expectantibus su

Book of Hours, Use of Nantes, or Book of Hours of Pierre II, Duke of Brittany, ca. 1455–57

Saint Martin

O God, in your goodness,
through the intercession of the blessed
* Martin,*
your confessor and pontiff,
protect us from all evil.

Orison from the Mass of Saint Martin

The head of the procession surges into the arch of the Grand Châtelet gate and enters Paris. But the rest of the horsemen, bundled up to their eyes, have halted behind Martin. He returns his sword to its scabbard after having cut his mantle. He has given half of it to a poor old man, barefoot and shivering with the cold, who bends his knee and presses his hands together in gratitude.

In a masterpiece of composition, the image revolves around the cobble-stone road, with its movement of the troops around the acute angle of a white stone parapet. The scene extends toward the Seine, where a small rowboat glides under the small bridge crossing to the medieval town.

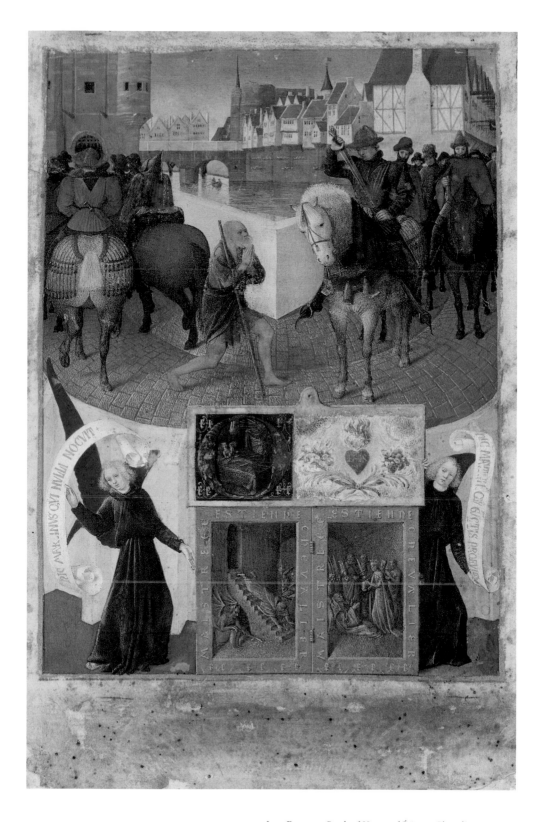

Jean Fouquet, *Book of Hours of Étienne Chevalier*, ca. 1455

Saint Christopher

Saint Christopher, pray for us,
For all those who travel voluntarily
or through need,
For all displaced persons.

Anonymous, twentieth century

114

The tall, brawny Saint Christopher, described in some accounts as a giant, strides across a river filled with charming boats, bearing the Christ child to safety on the opposite shore. Golden rays shower down on the infant, emphasizing his divinity, and the sky is studded with stars. As Saint Christopher gently grasps the Christ child's foot, the child clasps the saint's hair in a tender manner that underscores Christ's humanity. This intimate, even playful, quality is characteristic of this artist's miniatures.

The small scenes in the border relate further events from the legend of the saint—his quest to find and serve the most powerful ruler in the world. He first enters the court of a king and later serves Satan, but their fears and weaknesses are made evident to him. Saint Christopher turns instead to the Lord and to helping travelers and pilgrims.

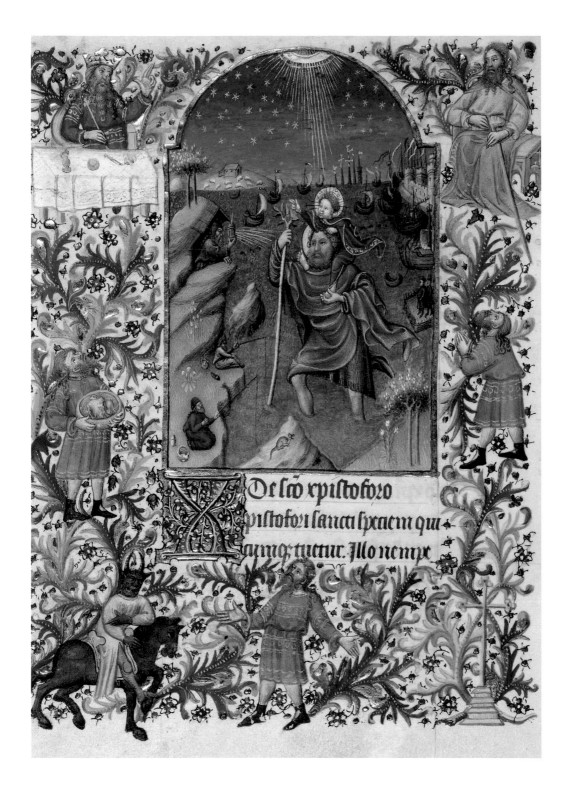

Saint Clare

All praise be yours, my Lord, through
Sister Water,
So useful, lowly, precious and pure.
All praise be yours, my Lord, through
Brother Fire,
Through whom you brighten up the night.
How beautiful is he, how gay! Full of
power and strength.
All praise be yours, my Lord, through
Sister Earth, our mother,
Who feeds us in her sovereignty and
produces
Various fruits with colored flowers and
herbs.

Canticle of the Creatures
by Saint Francis of Assisi

Under a trellis of black and white grapes that is burgeoning with wild roses and birds, Clare, dressed in the habit of a Franciscan nun, looks up from her prayer book at the beauty of nature as sung by her saintly friend, Francis.

Behind her, the walled city with its many steeples evokes Assisi, where both were born and which she miraculously saved, armed with a monstrance,* from the soldiers of Frederick II, who had laid siege to it.

In the margins, in the midst of foliage and flowers, a sort of winged sphinx with a caricatural head turns its back to a strange animal, half bear and half monkey, immersed in reading an open book.

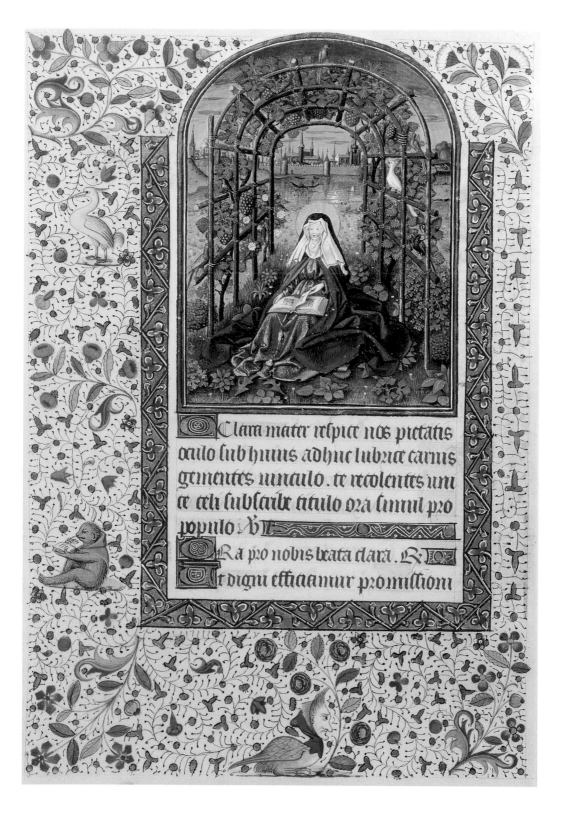

Book of Hours, Use of Rome, or Book of Hours of Louis of Savoy, mid- to late fifteenth century

Saint Paul

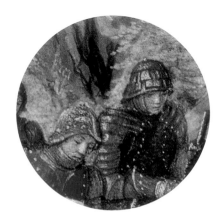

In a vast landscape where we glimpse Damascus in the distance, the Holy Trinity sends forth a divine ray that strikes down the persecutor of the Christians.

Already, Saul is no longer Saul. A nimbus forms around the head of Paul, still prostrate on his black horse, as turmoil grips the knights who accompany him.

After Jesus, Paul would become the greatest figure in Christendom, preaching the Gospel for a quarter century, from Asia Minor to Greece, and in Rome. A Roman citizen, he would be decapitated the very day that Peter was crucified there as a slave.

Under the main image, an atlas and four female savages support the initial of the text and the coat of arms of Étienne Chevalier.

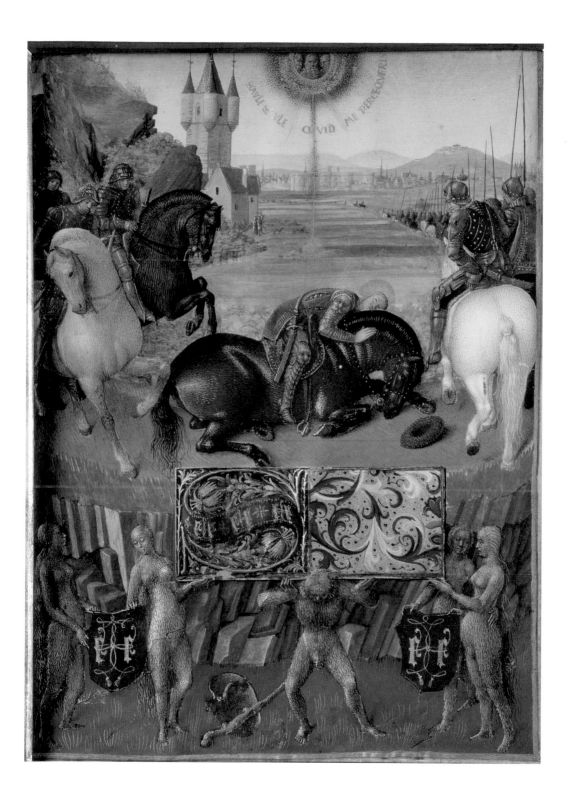

Jean Fouquet, *Book of Hours of Étienne Chevalier*, ca. 1455

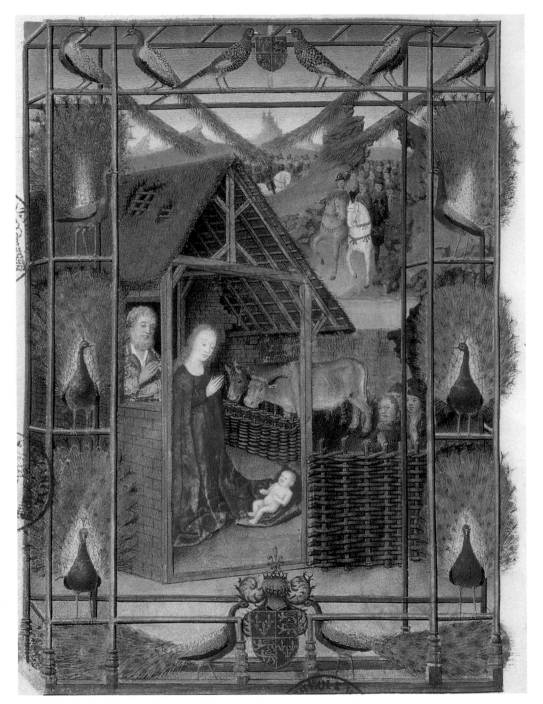

The Nativity, *Book of Hours of Charles of France, ca. 1465*

Vocabulary and Short History of Princes, Books, and Artists

◆

The Charles of France Master had an entirely original and charming idea for depicting the Nativity: an aviary in which twelve blue peacocks, symbols of immortality and resurrection, surround and illuminate the crèche. Six of them preen, fanning their tails, on either side of the cowshed. At the bottom, in profile, two support the coat of arms of the Duke of Normandy. These two birds are counterbalanced at the top by pheasants surrounding the same coat of arms. Four more peacocks point their long tails at the spot where the Star of the East usually shines.

In the midst of the exuberance of this decor is a very simple scene. The Virgin kneels in adoration before the newborn, who rests naked on her coattail. In the background, the donkey and ox blow on the child to warm him. Joseph on one side, the shepherds on the other, hands pressed together, express their wonderment.

In the distance, across the river, the superb procession of the Three Kings approaches.

ACOLYTE
Cleric who serves the mass at the altar (p. 57, *The Mass of Saint Gregory*).

BAUDRICOURT BOOK OF HOURS, CA. 1470
It was long believed that the coat of arms in *Praying Patron* (p. 53) was that of the Baudricourt family and that the lady was Anne de Beaujeu-Amplepluis, whose second husband was Jean of Baudricourt, royal chamberlain and future governor of Burgundy and Maréchal of France. That attribution now appears to be erroneous, but since there is no other sign of ownership in the manuscript, the designation continues to be used.

Two artists, one of whom was Jean Fouquet, worked on the illustration of this composite but very meticulous Book of Hours. The full-page miniatures were done by Fouquet between 1478 and 1481, a few years before his death.

BOOK OF HOURS
A private devotional book whose name is taken from the canonical hours, that is, times set by the church for reciting prayers. These hours are named for the way the Romans divided time: matins and lauds before sunrise, prime at sunrise, terce at nine o'clock, sext at noon, none at three o'clock, vespers at sundown, and compline at night.

BOOK OF HOURS OF CHARLES OF FRANCE, CA. 1465
The younger brother of Louis XI, Charles of France, a great bibliophile, was a patron to numerous artists. Among these was a very original unknown, subsequently designated the Charles of France Master, whom he commissioned to illustrate his Book of Hours. This illuminator, who demonstrated his inventive talent in the composition of his geometric canvases, was also an excellent colorist (p. 120, *The Nativity*). The patron's coat of arms, bearing the shield of Normandy, appears several times in the manuscript and allows us to date it. In effect, as a privilege, the brother of Louis XI received the Duchy of Normandy in 1465. The Charles of France Master, who was probably doing an apprenticeship in Poitou, is also the author of the charming *Book of Hours, Use of Poitiers*, ca. 1455–60 (p. 10).

BOOK OF HOURS OF ÉTIENNE CHEVALIER, CA. 1455
Rare is the Book of Hours for which we know the identity of both the patron and illuminator. That is the case for the *Book of Hours of Étienne Chevalier*, whose

miniatures were all by Jean Fouquet. Unfortunately, the manuscript is incomplete, dismantled in the eighteenth century. Today, we are aware of forty-seven pages, two of which are preserved in the Drawings Department at the Musée du Louvre while forty are in the Musée Condé in Chantilly.

Chevalier, royal notary and secretary, was appointed treasurer of France in 1452. He probably commissioned his book the following year. The treasurer, a cultivated and very pious man, lived in Paris in a luxurious residence where the Divine Office was celebrated daily. His Book of Hours is extremely personalized, and his initials appear on nearly every page.

The undisputed masterpiece of Fouquet, created on his return from Italy, the *Book of Hours of Étienne Chevalier* is the work of a fully mature artist. The greatest French painter of the fifteenth century treats his miniatures as if they were canvases. They occupy full pages and have no borders. Fouquet's mastery of space ranges from urban landscapes (p. 113) to a bedroom (p. 103). He portrays the details of daily life with grace and precision, in, for example, a midwife pulling up the sheets or a serving woman stirring water in a bucket.

The composition of his miniatures is always very intelligent, his colors serene, and his golds divine.

BOOK OF HOURS OF JEANNE OF NAVARRE, CA. 1340

This manuscript is a perfect example of a personalized Book of Hours. It bears the name of its patron, Jeanne of Navarre, daughter of Louis X (Louis the Headstrong) and Marguerite of Burgundy, crowned queen of Navarre in 1320. Jeanne of Navarre is depicted several times in her Book of Hours, kneeling in prayer (p. 79). We also see her giving alms under the protection of her guardian angel. Various artists worked on the Book of Hours, at least three of whom were trained in the studio of Jean Pucelle, who dominated the Paris School in the first half of the fourteenth century.

BOOK OF HOURS OF LOUIS DE LAVAL, LORD OF CHÂTILLON, CA. 1480

The coat of arms of Louis de Laval (1411–1489), profusely distributed throughout the manuscript, and the two admirable portraits of Louis, lord of Châtillon, that adorn the Book of Hours leave no doubt as to the identity of its owner, the "Grand Master and General Reformer of the Waters and Forests of the Kingdom of France," who died in Laval at age seventy-eight.

Louis de Laval commissioned his extraordinary Book of Hours from Jean Colombe, who was described by Charlotte of Savoy, wife of Louis XI, as a "poor illuminator in Bourges"! The colossal work (1,234 illuminations, including 157 full page) was executed in several stages, with the collaboration of various artists. The completed work is worthy of the obvious ambitions and talents of an astoundingly prolific illustrator.

BOOK OF HOURS OF LOUIS OF SAVOY, MID- TO LATE-FIFTEENTH CENTURY

This manuscript underwent numerous trials and tribulations: miniatures disappeared and the Savoy shields painted in the frames were rubbed out. But we know with certainty that the prince praying before the Trinity is Louis of Savoy, who married Anne of Cyprus in 1434. There are clues that indicate this, including the special place given to Saint Anne and Saint Louis. Two Savoy masters

illustrated this Book of Hours, which is remarkable for both the quality and quantity of its miniatures, that is, forty-five large miniatures, forty-seven historiated miniatures, and seventy-two medallions in the calendar.

BOOK OF HOURS OF MARGUERITE OF ORLEANS, CA. 1430

The coat of arms of the very young princess, who prays before the Virgin (p. 31), allows us to identify Lady Marguerite of Orleans, sister of the poet-prince Charles of Orleans. The illuminator apparently executed the miniatures for her Book of Hours around 1430, several years after Marguerite's marriage to Richard, Count of Étampes, son of Jean V of Montfort. The anonymous artist, known as the Marguerite of Orleans Master, probably trained in Paris and borrowed from both the Boucicaut Master and the Limbourg Brothers. However, he expresses his personal genius in the margins filled with witty elegance and whimsy.

BOOK OF HOURS OF THE MARSHAL OF BOUCICAUT, CA. 1405–8; 1477–80; 1490

Jean II le Meingre was a knight before he was named marshal and gave his name to the anonymous artist of his Book of Hours, the Boucicaut Master, who dominated French illumination in the early fifteenth century.

The very personalized prayer book is arranged in a unique fashion. Unexpectedly, the Suffrage of the Saints is placed before the Hours of the Virgin. We see Leonard, patron saint of prisoners, depicted between two captives, "all naked save their small loincloths" (p. 109). The marshal, having been imprisoned twice, thus demonstrates his special devotion to the hermit, who appears in only one other Book of Hours, that of Marguerite of Clisson.

The coat of arms and device of the marshal appear so often in the miniatures that historians find this surprising (p. 83). "The coats of arms and the 'motto' *What thou wilt* are almost indecently abundant, intruding on the religious scenes" (Charles Sterling). However, there is an explanation for this insistence, if we recognize in the motto the words of Christ at Gethsemane.

BOOKS OF HOURS OF THE DUKE OF BERRY

It is as a very great and generous patron of the arts that we remember Jean of France, Duke of Berry, who was born in Vincennes in 1340 and died at his Parisian mansion, Nesle, in 1416.

He lived surrounded by artists, architects, painters, and sculptors, in unheard-of luxury, in his mansions, castles, and palaces, when political conflicts allowed.

A passionate collector and refined bibliophile, he possessed more than three hundred secular and religious manuscripts, including some fifteen Books of Hours, the jewels of his library.

All of the Books of Hours (*Small, Large, Very Large, Very Rich,* and so forth) are magnificent. The adjectives in the titles are not actually meaningful. Only the *Very Large Book of Hours* is unusual in size.

BOUCICAUT MASTER

See *Book of Hours of the Marshal of Boucicaut.*

BREVIARY

Official book of liturgical prayer, written and controlled by the church. It contains the Divine Office, which varies based on the liturgical calendar. It is to be recited daily, at canonical hours determined by the church.

CENSER
Incense burner for the religious office, suspended from a small chain, which is swung to spread the odor of the incense, as a sign of homage (p. 51, *The Crowning of the Virgin*).

COLOMBE, JEAN
See *Very Rich Book of Hours of the Duke of Berry* and *Book of Hours of Louis de Laval*.

FLOURISH
Decoration composed of flowering stems winding in the margins of miniatures.

FOUQUET, JEAN
See *Book of Hours of Étienne Chevalier*.

HISTORIATED INITIAL
Initial whose interior is decorated with a small scene containing figures (p. 49, *The Wedding at Cana*; p. 61, *Jesus before Pilate*; p. 79, *Jeanne of Navarre Praying*; p. 87, *Office of the Dead*; p. 115, *Saint Christopher*).

IHS
Acronym for the Latin *Iesus, hominum salvator* (Jesus, the Savior of men) (p. 69, *Pietà*).

ILLUMINATION
In the Middle Ages, illustration of a manuscript with gold and luminous colors.

INRI
The Latin acronym for *Iesus Nazeremus Rex Judocrum* (Jesus of Nazareth, King of the Jews), written by Pilate and placed on the cross of Christ.

JACQUEMART DE HESDIN
See *Small* and *Large Book of Hours of the Duke of Berry*.

JUDAH
One of the tribes of Israel. The lion symbolizes its strength. It is said of David that he was a "son of Judah," and of Jesus that he was "of the House of Judah."

LARGE BOOK OF HOURS OF THE DUKE OF BERRY, CA. 1409
The elegance of the draftsmanship and the brilliance of the miniatures in this Book of Hours make it a French Gothic masterpiece. Not all are by the same brush. According to a 1413 inventory, the manuscript contained "great histories by Jacquemart de Hesdin and other of His Eminence's workers." Some illuminated pages of the *Large Book of Hours* are very similar to those in the *Very Beautiful Book of Hours of Our Lady of Jean of Berry*, particularly the one illustrating *The Wedding at Cana* (p. 49). In both cases, the conversion of water to wine is associated with the miracle of the multiplication of the loaves, which was, for Saint Thomas, Saint Augustine, and the church fathers, the first celebration of the Eucharist and the founding of the church. The young bride, who occupies the center of the image, symbolizes the church between the Old and New Testaments. In the foreground, the two figures represent the people of God. One is looking fixedly at Christ. The other is dressed in red like the bride and turns toward her, while her neighbor's arm, which looks as if it were split off from her own, seals their union.

LE NOIR, JEAN
See *Small Book of Hours of the Duke of Berry*.

LIMBOURG
See *Small Book of Hours* and *Very Rich Book of Hours of the Duke of Berry*.

LITANY
Long series of invocations by the religious leader with alternate responses by the congregation.

Lower Register
A miniature is "in the lower register" when it is located at the bottom of the page (p. 71, *Christ of Mercy*; p. 75, *The Baptism of Jesus*; p. 87, *Office of the Dead*).

Medallion
A small, round miniature (p. 111, *Saint Margaret Guarding Her Sheep*).

Miniature
A small image painted on a manuscript. If the image fills an entire page, it is called a full-page miniature (p. 15, *April*; p. 17, *July*; p. 19, *October*; p. 21, *December*, and so forth). If a page contains several miniatures, the largest one is called the "primary miniature" (p. 111, *Saint Margaret*).

Monstrance
Vessel in which the priest places the consecrated host between two glass disks, thereby exposing it for the adoration of the faithful.

Navarre, Jeanne of
See *Book of Hours of Jeanne of Navarre*.

Nimbus
A disk, most often gold, or luminous aura surrounding the head of a saint.

Obsecro te
The most important prayer to the Virgin in a Book of Hours. It is thought to have been composed by Saint Augustine the day he died. The prayer was recited to learn the day and hour of one's death, and to ask the Virgin to appear to the dying. According to the superstitious beliefs of the day, one would not die by poison, water, or fire on a day when it was recited (p. 10, *Young Woman Praying*; p. 31, *Marguerite of Orleans Praying to the Madonna*; p. 53, *Praying Patron*; p. 85, *Patron before the Madonna*).

O intemerata
The first words of the twelfth-century French prayer to the Virgin and Saint John. It appears in numerous Books of Hours. It may also be addressed exclusively to the Virgin. Sometimes both forms appeared, one after the other, in the same book (p. 55, *The Nursing Virgin*).

Patron
Person who commissions and pays painters and copyists to produce a Book of Hours.

Phylactery
Scroll on which a message reflecting the subject of the miniature is inscribed (for example, p. 113, *Saint Martin*; praises to the saint are written on the phylacteries).

Pucelle, Jean
See *Book of Hours of Jeanne of Navarre*.

Rohan Book of Hours, fifteenth century
The anonymous artist of the *Rohan Book of Hours* owes his name to the coat of arms of the Breton family that appears several times in the manuscript. However, we do not know the identity of the member of the house of Rohan who commissioned it. The originality of this coat of arms is even in question.

Probably living in Paris about 1415–20, the Rohan Master was entirely familiar with the great illuminators of his day, the Boucicaut Master and the Limbourg Brothers. But his strong personality, excessive temperament, and powerful emotions took him in a different direction. He broke the rules. Reserving the full pages for himself, he filled the space with his moving visions (p. 65, *The Crucifixion*) and images of tenderness (p. 55, *The Nursing Virgin*).

Rohan Master
See *Rohan Book of Hours*.

Savage
Medieval Europeans had an unclear concept of people from other continents (p. 101, *Saint Anne and the Three Marys*).

Four noblemen, dressed up as savages, were burned alive at a masked ball in 1393, when their flaxen costumes caught fire. King Charles VI was saved by the Duchess of Berry, who rolled him up in her cloak. This tragedy is known by the name of Bal des Ardents (Burners' Ball).

Small Book of Hours of the Duke of Berry, ca. 1385
Begun by miniaturist Jean Le Noir, the *Small Book of Hours* was continued by Jacquemart de Hesdin about 1385. At the duke's request, in 1412 the Limbourg Brothers added a delicate illumination, depicting him as an old man, leaving on a pilgrimage.

Suffrage of the Saints
Prayers recited in honor of the saints to ask for their intercession.

Use
The expression *Book of Hours, Use of Troyes,* and *Book of Hours, Use of Metz,* for example, indicates that the prayers in the manuscript were those used in the churches and monasteries in the dioceses of Troyes, Metz, and so forth. Patrons often chose their diocese, but many based their Books of Hours on the Use of Rome.

Very Beautiful Book of Hours of Our Lady of Jean of Berry, ca. 1404
This Book of Hours, whose calendar is very personalized, was commissioned from several artists: Jean of Orleans, the Parement Master, and the Saint Jean-Baptist Master, among others. All are very much canvas-quality paintings (p. 71, *Christ of Mercy*).

Very Rich Book of Hours of the Duke of Berry, ca. 1440
The *Very Rich Book of Hours* is a collective work and the last masterpiece by the three Limbourg Brothers—Pol, Jean, and Hermann—in the service of the duke since 1404. Together, they created the manuscript, modified it, and shared the work, until their contemporaneous death, probably of the black plague, at the Parisian mansion Nesle in 1416, the same year as their patron's death.

The book would be taken over by an unknown artist around 1440 and completed by the great Jean Colombe around 1485, for Charles I, Duke of Savoy.

Collection/Location

127

129

Bibliography

Avril, François. *L'enluminure gothique, 1200–1420.* Paris, 1995.

Avril, François, and Colette Beaune. *Les manuscrits des rois de France.* Paris, 1997.

Avril, François, and Nicole Reynaud. *Les manuscrits à peintures en France 1440–1520.* Paris, 1993, 1995.

Bazin, Germain. *Jean Fouquet.* Geneva, 1942.

Bazin, Germain. *Jean Fouquet: Le livre d'Étienne Chevalier.* Paris, 1990.

Boespflug, François, and Eberhard König. *Les Très Belles Heures du duc de Berry.* Paris, 1998.

Cazelles, Raymond. *Les Très Riches Heures du duc de Berry.* Foreword by Umberto Eco. Paris, 1988.

Chancel-Bardelot, Béatrice de. *Les Larmes de la Vierge* (exhibition catalogue). Bourges, 2000.

Chatelet, Albert. *L'âge d'or du manuscrit à peintures en France au temps de Charles VI et les Heures de maréchal de Boucicaut.* Dijon, 2000.

Dufournet, Jean. *Les Très Riches Heures du duc de Berry.* Paris, 1995.

Durrieu, Paul, Count of. *Les Très Riches Heures de Jean de France, duc de Berry.* Paris, 1904.

Focillon, Henri. *Art d'occident: Le Moyen Âge roman et gothique.* Paris, 1983.

Gautier, Léon. *Choix de prières des manuscrits du XIIe siècle.* Paris, 1861.

Harthan, John Plant. *Books of Hours and Their Owners.* London, 1976.

Harthan, John Plant. *L'âge d'or des livres d'Heures.* Paris, Brussels, 1977.

König, Eberhard. *Les Heures de Marguerite d'Orléans.* Paris, 1991.

Leroquais, Canon Victor. *Les livres d'Heures manuscrits de la Bibliothèque nationale.* 3 vols. Paris, 1927, suppl., 1943.

Mâle, Émile. *Les Grandes Heures de Rohan.* Geneva, 1947.

Mâle, Émile. *L'art religieux de la fin du Moyen Âge en France.* 5th ed. Paris, 1949.

Meiss, Millard. *French Painting in the Time of Jean de Berry, the Limbourgs, and Their Contemporaries.* London and New York, 1974.

Meiss, Millard. *Les Belles Heures du duc de Berry* (facsimile). New York, 1975.

Meiss, Millard, and Marcel Thomas. *Les Heures de Rohan.* Paris, 1973.

Pastoureau, Michel. *Figures et couleurs: Étude sur la symbolique et la sensibilité médiévales.* Paris, 1986.

Plummer, J., and G. Clark. *The Last Flowering: French Painting in Manuscripts, 1420–1530* (exhibition catalogue). New York, 1982.

Porcher, Jean. *Les Grandes Heures de Rohan.* Geneva, 1943.

Porcher, Jean. *Les manuscrits à peintures en France du XIIe au XVIe siècle* (exhibition catalogue). Paris, 1981.

Reynaud, Nicole. *Jean Fouquet* (Louvre Museum, Painting Dept. Records, No. 22). Paris, 1981.

Schaefer, Claude. *Fouquet, les Heures d'Étienne Chevalier*. Göttingen, 1994.

Sterling, Charles. *Les Heures d'Étienne Chevalier*. Paris, 1971.

Sterling, Charles. *La peinture médiévale à Paris, 1350–1500*. Vol. 1. Paris, 1987.

Sterling, Charles. *La peinture médiévale à Paris, 1350–1500*. Vol. 2. Paris, 1990.

Thomas, Marcel. *Les Grandes Heures de Jean de France, duc de Berry*. Paris, 1971.

Wieck, Roger. *Late Medieval and Renaissance Illuminated Manuscripts, 1350–1525, in the Houghton Library*. Cambridge, 1983.

Wieck, Roger. *Time Sanctified: The Book of Hours in Medieval Art and Life*. New York, 1988.

Acknowledgments

The author and publisher warmly thank:

Mme Marie-Pierre Laffitte, Curator General of the Département des Manuscrits Occidentaux, Bibliothèque Nationale de France, Paris

Mme Jacqueline Labaste, Head Curator of Bibliothèque Mazarine, Paris

M. Nicolas Sainte Fare Garnot, Curator of the Musée Jacquemart-André, Paris

Mme Emmanuelle Toulet, Head Curator of the Library of the Musée Condé, Chantilly

The author expresses her profound gratitude to Claude, Françoise Romaine, Hélène, and Jacques.

Photograph Credits

Cover: *The Crowning of the Virgin* (detail), photo: BnF, Paris

All photographs of miniatures, selected and collected by the author, are from the Bibliothèque Nationale de France, with the exception of the following reproductions:

p. 19, *Month of October*; p. 91, *Job on His Dung Heap*; p. 103, *St. John the Baptist*; p. 119, *The Conversion of Saint Paul*: Musée Condé, Chantilly, photographs: AKG, Paris.

p. 33, *The Annunciation*; p. 47, *The Flight into Egypt*; p. 115, *Saint Christopher Carrying the Christ Child*: photographs: The J. Paul Getty Museum, Los Angeles.

p. 37, *The Nativity*; p. 41, *The Annunciation to the Shepherds*; p. 57, *The Mass of Saint Gregory*; p. 83, *The Trinity: God the Father Welcoming Christ on the Cross*; p. 105, *Saint James the Great*; p. 109, *Saint Leonard*: photographs: Institut de France–Musée Jacquemart-André, Paris.

p. 113, *Saint Martin*: Graphic Arts Dept., Musée du Louvre, Paris, photograph: RMN.

p. 120, *The Nativity*: Bibliothèque Mazarine, Paris, photograph: Jean-Loup Charmet.

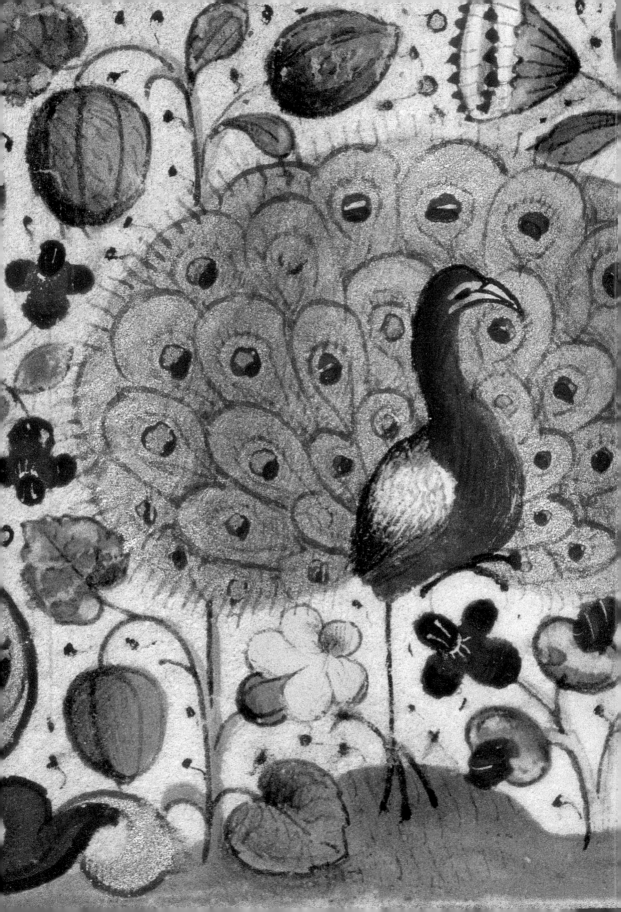